With Bloom Upon Them
and Also with Blood

"WITH BLOOM
UPON THEM
AND ALSO
WITH BLOOD:"
A HORROR MISCELLANY/ JUSTIN PHILLIP REED

COFFEE HOUSE PRESS Minneapolis • 2023

Coffee House Press books are available to the trade through our primary distributor, Consortium Book Sales & Distribution, cbsd.com or (800) 283-3572. For personal orders, catalogs, or other information, write to info@coffeehousepress.org.

Coffee House Press is a nonprofit literary publishing house. Support from private foundations, corporate giving programs, government programs, and generous individuals helps make the publication of our books possible. We gratefully acknowledge their support in detail in the back of this book.

LIBRARY OF CONGRESS CATALOGING-IN-PUBLICATION DATA

Names: Reed, Justin Phillip, author.
Title: With bloom upon them and also with blood : a horror miscellany /
 Justin Phillip Reed.
Description: Minneapolis : Coffee House Press, 2023. |
Identifiers: LCCN 2023020879 (print) | LCCN 2023020880 (ebook) |
 ISBN 9781566896917 (paperback) | ISBN 9781566896924 (epub)
Subjects: LCSH: Horror films—History and criticism. | LCGFT: Essays. |
 Poetry. | Film criticism.
Classification: LCC PS3618.E435653 W58 2023 (print) | LCC PS3618.E435653
 (ebook) | DDC 818/.6—dc23/eng/20230512
LC record available at https://lccn.loc.gov/2023020879
LC ebook record available at https://lccn.loc.gov/2023020880

Texts in this book have previously appeared in the *Adroit Journal, ANMLY, Bennington Review, Catapult,* the *Columbia Review, Cotton Xenomorph, Flypaper Lit, Fonograf Editions, Jewish Currents, Poetry Is Currency,* and the *South Carolina Review.* "Killing Like They Do in the Movies" also appears in *The Best American Essays 2016.*

PRINTED IN THE UNITED STATES OF AMERICA

30 29 28 27 26 25 24 23 1 2 3 4 5 6 7 8

for Pop & Wayne
& their best hats

TO SEE WHAT YOUR INSIDES LOOK LIKE

With Bloom Upon Them
and Also with Blood

The danger . . .

is to substitute one romanticism

for another.

—James Baldwin

The only perversions that can be

comfortably condemned are

the perversions of others.

—*Ganja & Hess*

In reality we ourselves make cinema by living it:

that is, by existing practically; that is,

by acting . . . By living, therefore, we represent ourselves, and

are present at the representation of others.

The reality of the human world is nothing other than

this double representation in which we are

both actors and spectators:

a gigantic happening,

if you like.

—Pier Paolo Pasolini

You gotta be careful who you play with.

Everybody aint playin.

—Young M.A

BEGINNING WITH ALTERNATIVE TAGLINES FOR *MA*

for Lamar

A person who has been trapped in what they need learns to make need a trap.

A person gets trapped in how you need them and refuses to call it a trap, and instead y'all agree to call it love.

In her poem "I Have a Method of Letting Go," Khadijah Queen writes of her mother—like mine, a smoker—*She is familiar with duty & made me so / I can't live on that loss.*[1]

I think I am a stranger to duty. I recall what many thought they had a duty to teach me about manhood or about malice disguised as intellectualism, and I don't really want to hear it, can't help it. But I know what my mother has given; what, because it was a gift to my life, she decided was not loss.

She is familiar with duty & made me, [therefore . . .]
She is familiar with duty & made me [al]so [familiar with duty.]
She is familiar with duty & made me so [that]
 I can't live on that loss.

•

In a house in South Carolina where for years my family gathered after church, on Easter, for Christmas, for the unofficial family reunions, before and after every funeral, where once my six-year-old mind attempted to comprehend the fact of death from within deep breaths between the folds of an old leather sofa . . . In that house, the diabetic women who raised us seem to end up netted in need and looking each other in the

1. From Queen's poetry collection *Anodyne* (Portland: Tin House, 2020).

mouth. Sucking on a Werther's butterscotch drop summons the sensations of that place as though they were gold deposits in the glands, tongued loose like meat at the hip of a gold tooth. Hips I clung to til I was told clinging weakened me are hips I miss after the twenty years it took to either side-eye that absurdity—*how can knowing well the smell of creatures to whom you are most vulnerable kill you?*—or acknowledge that, yes, it can. Spiders don't stare each other down from opposite corners of the same room, but people do and have a funny way of feeding resentment in peace. Perspective takes patience to earn, and I'm only just becoming a patient person.

It's true, I've been away too long from the ones who speak my name's first syllable so slowly they seem to still be celebrating the moment of my birth in every possible musical note. But it's worthwhile to be accurate about what easily avails itself to romance, especially that urge toward a kind of small-town idyll that paints your Black momma as everybody's.

Honestly, it was like a myth of peas—not that exact aroma, but what upholstery pressed daily by the same asses will make of poorly ventilated air. Roaches. Bare feet, white flakes of skin, ankles we'd have to keep an eye on. Snuff tins stacked on dusty dressers, and clutter from which someone with an archivist's mind for caregiving could keenly select the right size of needle-eye in a matter of seconds. That sleeping sewing machine. A framed photograph of a cloud formation that lets you envision almost any face on Jesus. We called my uncle Snake, but his name is Carl. A cousin Pig, his sister Ladybug. Staggered portraits of graduates and military officers with the gravest gorgeous faces. Ankles in braces quick as you could look away. Three or four unopened glazed cakes from the IGA across from the funeral home. Two-liter sodas in bulk against the walls, carbonation sitting in them like the truth of which children Granny actually raised sat in more mouths than would tell it while she was alive. Thuds of those children's children's children threatened new bruises in the drywall of the hallway. The convalescent room was cold. After a time, the air conditioner and the breathing machine are distinct to the ear though interchangeable in function. Always somebody trying not to die. Root beer and witch hazel. We make a diamond with our skinny legs, press our sweaty soles together, and roll the ball back and forth between our knees.

Knots on switches from the tree you're lucky to strip yourself. Some times my people seem to take a season to express a thing they noticed about you; then, they do in full red bloom and possibly with bees. *Fullashit n fool as hell.*

Fears and ants kept me from climbing the magnolia. Rice froth draped the pot sides like tablecloth. Chicken bog I'd daydream about throughout the whole First Sunday service. Esther Mae pulled a plug of chew from her cheek and set it next to her plate; nobody named her disorder all those years, and every one of us was mean enough. Low-thread-count carpet burn. Bulge of what one hopes is air in the linoleum. Rotary phone in the kitchen wall to dial the house across the cabbage patch. Perpetuity of a poinsettia in green foil. Finished false-wood siding on an ancient radio, permanent centerpiece of the shelf of five-by-seven baby pictures. Scrapple pushing out of plastic wrap. Pocketbook thick as a fig with intrigue and chewable peppermint, but you don't stick your hand in there, just bring it here.

Some needs I never knew in that place because of who shaped it and how, and some needs I would learn. All of it moves now in the room of melancholia, meaning that even as I stand at the door I cannot reenter. Ask me how I ever looked away, and I'll tell you there were enough holes in it to see out of. Or I wonder if it provided so well that many of us had the fitness to feel dissatisfied and to pursue fulfillment elsewhere. Folks have to have a measure for success in child-rearing; why not this?

•

Not everybody's momma, my Nana is "Ma" to many people who haven't seen their mothers in years, whether after death or some specific incapacity grown folks call their business. "Aint no need in me getting depressed," she tells me she told her doctor. "I'm eighty-five years old. This heart been beating a long time."

My Nana is not a saint. I don't believe in saints who live to be eighty-five.

•

Yes, *Ma* is a silly film. How dare it insinuate that Juliette Lewis would take care of Octavia Spencer's daughter after what happened in that home, in that tiny Ohio town. And in no fantasy anywhere does veterinarian Allison Janney actually work harder than a Black woman who still has a job. But I don't think that Sue Ann's (Spencer) retaining her individual mind, however twisted to vengeance and committed to violence, is an absurd premise. Or that her choosing to burn with the collapse of that mental extension, the terrible house, is impossible to entertain (though it doesn't entertain me). If you could not otherwise escape the devastation the monster of your desire causes as it crisscrosses its own tracks, how else to hell with it? Maybe I take everything too seriously. Tate Taylor wants to tell us about what and who have happened to Black folks in Jackson, Mississippi—what ought to incur nightmares of grotesque vengeance—but he can't resist the predictable interventions of bad wigs, high drama, Madonna-whore drag, and the persistently facetious myth of the American Midwest as an unaccountable setting. Tate Taylor is a white gay Gemini who, after the success of *The Help*, lives in a plantation house that no one has burned.[2]

I read Sue Ann as drawn and excruciatingly torn between her duty and her individual mind.

Is this oxymoronic? I'm trying for a basic definition of duty because perhaps, as I said, I don't understand it. I also don't want to be caged in it, but I'm beginning to suspect the cage is the thing about it. Outside, for instance, this country crests the planet in both arrogance and illness, the moon sucking on the albumen of US exceptionalism. Entitled to its disapproval, the individual in me wants to say *we* have distinguished the individual to death, but the collective of voices that bugs my sweaty neck knows better yet that this is about private property—which time is. Ever since people commodified measurable time, we've been owning time, owing time, reclaiming time. And now the people I believe I love want time; they want time I've been calling *mine*. If I believe I love them, then it follows that I'm duty-

2. "Tour *The Help* Director Tate Taylor's Renovated 1830s Mississippi Mansion," *Architectural Digest*, February 2, 2016, https://www.architecturaldigest.com/video/watch /tate-taylor-house-tour-video.

bound to have time for them. If we love each other, then we share time, we pay it forward, and no one hoards it. This seems to be the ideal.

I have been not an ideal individual. There is no one alive I want to hear from every single day, and every day I assay and assail the resolve to die confidently alone. What if my mother had had my mind? What if no one had felt obliged to share time or break silence in that convalescent Carolina house? Sue Ann's individuality resented her duty. That resentment culminated infernally. Something is burning about me.

The most dutiful people are probably the least likely to hem themselves up in such philosophy. Seems like no one who takes good care of their people thinks much about a debt of selfhood, because what self would there be in the absence of that care? I am just as probably not the stranger to duty I'd like to be: I envy folks who don't become phantasms of themselves in the faces of family. Lamar, for me to come to you in the airs of a child is no longer permissible or responsible. That you have never owed me an iota of care but gave because I was there to receive it is a model I've acknowledged many times in this life and opted not to make my own devotion. I can see, even as I plead with Jonah to let me never fail at love, that I have done.

Naming failure is not an intrinsically redemptive act. We, the poets of what is called "witness," know this.

•

On the day I'm burrowing through Rita Dove's *Collected*, after Kate Bernheimer's "Fairy Tale Is Form, Form Is Fairy Tale" sent me seeking the poem "Beauty and the Beast," Nabi is online, on video, making come alive Dove's "Mother Love." It begins:

> Who can forget the attitude of mothering?
> Toss me a baby and without bothering
> to blink I'll catch her, sling him on a hip.
> Any woman knows the remedy for grief
> is being needed: duty bugles and we'll
> climb out of exhaustion every time

A double sonnet, Nabi tells us, so I begin to unriddle its rhyme scheme, which appears at first, like its speaker, to deliver according to its face. Should've known some shit was up the second the poem opens with an obvious rhyming couplet, a symbol of closure, completion, or balance typically reserved for endings. Surrounded by sweet chiming assonances, *grief* and *need* full of teeth, and expected echoes that disappear (what rhymes with *mirrors* here?), led by the slick hand of curious music, I go blindfolded out of the poem's generally speaking and into its scene—but I go in faithfully *because*, I think, *I've seen this:* impulsive maternity, whatever made it possible for mommas and aunties to exchange nights away. Hip to hip, unblinking, slinging us. Yesterday my mother told me I wouldn't sleep alone til I was three. Duty bugling eleven hundred nights. Is exhaustion a static altitude, or do its slopes grow steeper? From what depths did she have to stay alert? I'm doting on Dove's bewitching my ear and only just considering that a young woman learned to listen from the pit of weariness for my distinct repetitions.

(What rhymes with *mirrors* slides inside the line: *girls* peer in*to as their fledgling* heroes *slip*. Nothing as perfectly representative as literal reflection belongs in this poem, nothing so fake. The mirrors are *one-way*.) Another woman, urged by her "bouquet of daughters," comes to Dove's speaker, hoping she will nurse the woman's only son—the way the kids in *Ma* corral around Sue Ann, thirsty for her chill and her yield, expecting Octavia to play Octavia's role. Considering its form inversely as the opening suggests, here's the final octet of "Mother Love."

> I decided to save him. Each night
> > I laid him on the smoldering embers,
> sealing his juices in slowly so he might
> > be cured to perfection. Oh, I know it
> looked damning: at the hearth a muttering crone
> > bent over a baby sizzling on a spit
> as neat as a Virginia ham. Poor human—
> > to scream like that, to make me remember.

She finishes, as she started, in the problem of memory. If this is an American problem, there's some idea who can forget and what's to remember. If this is a personal problem, it is still American. I imagine the speaker remembers the way my mother's cesarean scars did the third time. "Slowly so," "Oh, I know," the speaker coos. *Crone* either merely or must slant-rhyme with *human*.[3]

•

A plot summary: *Demented in the aftermath of other people's malice, a mother endangers her daughter in a deluded attempt to protect her from the yet indelible dangers beyond their doors.*

Or plot keyword: *Racial pathology.*

Or scholarly review: "Bad Mammy Drama: Imagining Black Mothers Somehow Having Time to Toy with White Folks' Lives from *Chloe, Love Is Calling You* (1934) to *Little Fires Everywhere* (2020)."

•

Queen's "Afterlight Erasure" begins

The pain is willing &

 I suffer—

 A good mother does what it takes.[4]

3. This formal note is interested in Zakiyyah Iman Jackson's reading of, as I understand it, Black women's nursing and maternal labor / maternal forms as having been made to represent the historic scientific boundary between *human* and otherwise. See Jackson's "Suspended Munition: Mereology, Morphology, and the Mammary Biopolitics of Transmission in Simone Leigh's *Trophallaxis*," *e-flux*, #105, December 2019, https://www.e-flux.com/journal/105/305272/suspended-munition-mereology-morphology-and-the-mammary-biopolitics-of-transmission-in-simone-leigh-s-trophallaxis/. (H/t Lauren Francis.)
4. Queen, *Anodyne.*

My people are not by any nature harder to show up for. By unnatural imposition, their lives are profuse with occasions that require presence. There are succinct mutilations and removals that the word *disparity* obliterates. Signifying won't suffice. My grandmother died of an aneurysm. My mother was nine years old. My mother's first husband died of thrombosis. He was twenty-two.

I am heating canned salmon with sweet onions. I am thinking of Momma working nights at Bingo-Rama. Overtime Saturday mornings in gray cubicles away from the grace of natural light. Associate's degree she pursued in night school, briefly. The long catalog of things we had that were not free, beginning with a bucket of rice beneath the kitchen sink. Her collection of elephant statuettes—especially the one handmade of hundreds of frosted shells, tiny cockles and whelks—and what moment opens in the bloom of Newport smoke, exhaled in pursuit of the falsetto in "Bennie and the Jets," before it escapes through the cracked driver's side window: These were places she knew she could always find herself, I see that now. Either I'm quiet during Elton and Prince or only as loud as she. Her aesthetic attraction to these flamboyances versus the loop she believes my loving another boy threw her for.

—What's to forgive? I couldn't "get [my] crooked ass straight," but I wasn't kicked out. I didn't know hunger in her house unless I chose it. But suddenly, "this act of profound generosity that created being" had encountered its limit.[5] Why am I attached to our detachment, the singular scene of her lapse in selflessness? Because it has been my only occasion to reciprocate discipline. Because it was the preeminent instance in which I was looked in the eyes and refused childhood. From the pressure of that moment, over seventeen years, I have effused and cooled like an island. I am rooted to it. And perhaps because she is not God and could not erase her failure but persists in contending, as author, with the narrative in which that failure lives, my love for her is terrible and absolute.

5. This quote is one way that M. NourbeSe Philip describes motherhood while in conversation with Rachel Zucker on the *Commonplace* podcast. "Episode 84: M. NourbeSe Philip," *Commonplace*, Episode 84, March 25, 2020, https://www.commonpodcast.com/home/2020/3/25/episode-84-m-nourbese-philip.

But first—after I had declared a need, had broken open my face like a tree nut to mutter "I love him" but meaning "Will you still imagine me, maker of me?" and was left lacking but alive in the consolation of her duty—for a while, I was an absolute terror. Things that were not free: therapists, psychiatrists, nutritionists, George W. Bush–era gasoline, Seroquel, Geodon, Zoloft, Wellbutrin, Prozac, and what it takes to meet the continuity of individual nights in which your child might bleed himself, starve himself, kill himself, or further disappear. I became the shape with blades and eyes in the dark, the room with a knob best left unturned. And I was hers. I suffered a good mother.

THE BRAIN IN SLEEP PRESUMES THAT ROOFS EXIST WITHOUT BOTHERING TO BELIEVE IN THEM

The night inside the night at 3 am keeps pulsing desperately like the lungs of something buried alive, or straight people fucking to make children when they're afraid and have good reasons to be. I dream dreams that have only the markers of domestic horror. Scouted locations the rambunctious toddler of the subconscious scatters across the hours. Murky water glass in a garage, varnish peeling from the rolltop desk beneath, a stepfather of suspicious origin on his way home from there: that's the air. Against plaster walls indoors, the threat of ghost sisters comes faint as leaks getting started. *Something happened here* always means that something will. The uncanny hesitates to materialize. It wafts aromatically or flashes, hyperventilates in camera. Its image stutters like a valve between doubt and submission: *what went we what went we.*

What is it I want from horror? What does it want with me? What is it?

What is it? Anything as pitiful as pigeon wings in retreat. Partial and random flaying of a person alive. Signs of a struggle. The knees, breasts, and ass cheeks of Billy Bob and Halle Berry in *Monster's Ball*.[1] Wings, wings, nervous bird. How it's filmed from the vantage of shame, *in* shame as through a hole in the wall, as though the lens had been lubricated with humiliation.

1. *Monster's Ball*, directed by Marc Foster (2001; Lions Gate Films).

"Shiver" is the word I was looking for. Bird in a cage. Bird in a cage of fingers.

In the climactic scene of riot police beating Angela Bassett down in *Strange Days*, in the streets on the eve of Y2K, confetti falls.[2] How long it takes the crowd to stop it might be the first time I fully appreciate the implication of eternity. I'm something like six or seven. Between fidget and fixity like cockroach legs. A dress that is probably the size of a cocktail when folded leaves her skin against the asphalt. Close-ups on her agony (it's Angela Bassett *acting*, right?) and the many black batons kicking the air attempt immortality by light speed into my visual future. I'm a child immobilized in viewership, letting happen, and for twenty years I remember nothing more about the film—maybe not always that it is a film. An isolated, projected loop of a brown-skinned woman with black braids battered with billy clubs belabors the black-box theatre of the skull. Instead of nightmares, I have an archive. Some evenings my mother goes places without me.

2. *Strange Days*, directed by Kathryn Bigelow (1995; 20th Century Fox).

From time to time inside this mystery I won't survive, I'm given the gift of a jiltable eye that paints the shape of a man who angles forth to pour his crotch into the head of some unseen, kneeling, gorging sucker, buckles there, before softening into parenthesis to gather his gravity and thrusting again, fast fucking that face my hungry public mind unearns. Their shape is red and gold on this earth's continual turn, a weird near-winter fire jerking my nerve through annoyance at like-minded gnats' dusting mud-musky deer paths dead leaves leave discrete while, slowly, the pink-rimmed sun unbuttons my fuzzy skull and pulls out the horn of the holy hour. Swimming in its bell is highway hum, hill-split winds, hurry of blood past my temples, and no whispers, no whimper.

Recognition's precise zipper pinches me: what men tick here between trees are trees, trembling in violent sleep.

When I was little, Brandon and Quentin from next door told me that the Klan was in the woods behind our houses. I was for a long time afraid to jump the ditch that split their backyard from the thick growth of pines into which they'd disappear soon after I was sent over to "go play." And there were water moccasins in the bottom of that ditch, someone told me too. Eventually I hated to play with other boys.

On a seventy-two-degree Sunday in May, I throw throat on a mausoleum's concrete knee for an audience of big-headed cherry blossoms. Scientists find the virus in semen. The hill hunches laboriously green. The brown plots below bear small names. Zooming out from here corrects the pace of my disintegration; so does zooming in.

So a couple fucks in a cemetery.[3] You notice the narrative leaning head-long into the hole of their punitive deaths. You can tell by how the camera disregards the usual stations of self. The face and the eyes are discontin-ued as sites of interpretation the scene can encompass. Here instead is a plump butt sliding out of denim, an ample tit, painted lips appliquéd among hands and hips. Dismemberment already determines them.

And in this way, when two rednecks rape the daughter in *A Time to Kill*, by slicing the subject into interrupted visual fragments, the camera performs its own brutal act.[4] Mutilation by re-concatenated frames. At the shot of her bloody ankle, my uncle, I remember, exclaims about "her body part." Sam-yell Jackson hopes they burn in hell, hopes to hell they burn.

3. See, for example, *Phantasm*, directed by Don Coscarelli (1979; AVCO Embassy Pictures).
4. *A Time to Kill*, directed by Joel Schumacher (1995; Warner Bros).

In a nest of any insect, its orgy of effort suggests
one must relinquish self-disgust to get work done.

I recognize terrible places by their glow. Red breathes from the inside
like a prolapsed rectum. In this one a severely Nordic person makes a
meal of a girl who looks like Chloë Grace Moretz. This is a dream I had.
The irony gets lost when we see the big blonde clean the bones. We are a
group and tie her up and need something she has, having nothing to do
with the casserole of Chloë Grace girl. Others of my gang are young and
distracted and the big blonde exploits that, almost escapes the restraints.
We are not on fuckin vacation, I tell the kids, when the blonde's Black
lover, bewildered and linebacker-bodied, emerges mercenarily out of a
nowhere that slowly adheres to the shapes of a trailer's bathroom. Did
someone shoot him? I think someone was shot.

KILLING LIKE THEY DO IN THE MOVIES

In 1996, I knew nothing of the word "lynch," only that it was also the last name of a girl in my grade whom none of us talked to.

They found Uncle Craig hanging from a tree on McIver Road. I remember that his skin was darker than most of the skin I had seen, remember thinking later that his body and the tree must have shared a darkness. Crooked silhouette of limbs and fingers and trunks, all that Carolina morning burning holes through it. I shouldn't have been able to beautify that image.

At seven, I knew only what it was: a hanging. Not who, not why, and not since when.

A chain of associations drags me out of sleep. I dreamed someone tattooed on my forearm a talismanic pentagram. I surface recalling the gruesome kills of Michael Myers throughout the *Halloween* franchise. All the white teenage girls, strangled or bleeding out, and then Tyra Banks: gutted and hanging by the neck from a wire. I want a metaphor for how these scenes are imagined—how dust and waste and forgotten things might collect in the bed of a huge river; how I could pick up a small stone formed from centuries of this and wonder about its weight in my palm, the color contrast, and never question the river, what cut across it, sank through it, floated on its surface.

It isn't like Michael Myers had never hung up a body before *Halloween: Resurrection.*[1] By this eighth entry it was one of the killer's hallmarks to suspend a victim, cocking his head in odd curiosity or appraisal of his work. It's that Banks's Black woman's body, silent in the center of the room, reveals the grotesque as no curio but a well-known wound. I've been failing to write a poem that ends with the lines *this body didn't teach you all / you know about gore, but damn / if it didn't try.*

1. *Halloween: Resurrection,* directed by Rick Rosenthal (2002; Miramax).

I hadn't thought about Uncle Craig in I don't know how long, had forgotten ever having known someone who was lynched, and this lapse is what troubles me when I throw back the sheets. I ask my mother for details, and she calls from work, and yeah it had to be about '96 because that was the year after Daddy died and left her with two sons, the year my sister was born, and she wants to send me pictures of Craig's daughter's daughter, who is beautiful and in one picture is holding my baby niece, and our girls are always beautiful, but yeah, she doesn't think they ever found who did it, doesn't think they were really looking, no use in me being mad about it now, she's gotta go visit Craig's wife Aunt Deborah in Columbia and see the new granddaughter, and she's gonna send me all these pictures of the beautiful girls.

•

Wes Craven died. Brain cancer. Violent but relatively goreless, considering. Features and images went up online to commemorate what Craven had given us. I wonder if maybe lately I don't have much grief left on reserve for famous white men or if I just have trouble mourning in general, but in a predictable desire for homage and nostalgia, that evening I decided to watch *A Nightmare on Elm Street* (1984), Craven's classic franchise-starter in which razor-fingered Freddy Krueger stalks the dreams of four archetypal suburban kids.

I rarely think of Craven, but I can easily visualize many of the kill scenes that made him famous, his killers iconic. I keep a mental library of the kills. I often call on them while writing poems, as though for a diction of fantasized violence, a showcase of its articulations. This is what Craven and his peers have given me.

A few minutes into *Nightmare* I began to dread the rest of it. Each scene seemed to climb toward the least red death in the film: that of Rod, the first victim's dark, "rough-edged," pretty-faced boyfriend, the prime suspect in her death; Rod, whom Freddy—existing somewhere between shared delusion and poltergeist—hangs by a bedsheet in what will

appear to the always aint-seen-nothin cops to be an otherwise-empty jail cell.

It's a bloodless kill. It looks to the adults like a simple guilt-fueled suicide. I am meanwhile no longer watching the scene of a film. My ears fumble the dialogue. My eyes receive information from the laptop screen, but my mind is digressing, recycling props kaleidoscopically, replacing Rod with Sandra Bland. That I can color the glue-and-scissors details around Bland's death with a scene as outrageous and inventive as this one irritates me. The story from the Waller County jail has as many cuts, edits, and special effects as Craven's slasher. Black ghosts dangle in all the corners of my horror flicks lately, even when I'm not looking.

Upon discovering Rod's body, the protagonist Nancy shrieks the beginning of her long frustration. She knows what's killing her friends, what's coming after her. Knowing makes her crazy. Disrupting everyone else's resistance to knowing makes her the problem.

•

When I enter the bar, its walls are talking loudly amongst themselves. Dying woods might always be filled with falling trees regardless of whether an eavesdropping ear would hear. One wall has its mouth full of Josephine Baker and all her feathers. Another holds Miles Davis in the throat of its holler, his trumpet paused mid-rapture. There are others, bound in frames, jazzing up the space. All the other patrons are white. Their beer voices slap up the Black talent and bounce back. I come like a gap in a white caravan and grit my teeth against the din of it. Down an aisle of stools and nondescript tables, a vintage-looking man plays a vintage-looking piano, grinning at the skinny woman thinly singing another jazz standard, her hair in a vintage-looking bun. A young New Yorker sits across from me and gets bored with my pointing out how white spaces have "this thing" for making ornament of nonwhite strife and achievement, which are often difficult to tell apart. I'm also bored. I'm trying to understand this nearly ubiquitous need for the Negro edge.

Festive decorations, tricking the light. Somehow I've become a conduit for haunting—a needle pushed across the black cut, which spins even when I don't want to lower my nose to it because maybe tonight my spine needs respite from the violent signals of memory and literacy. How hopeful. Not this night. What happens when I'm not here? What am I assumed to cosign when I am here? Same answer. Sometimes, when I say I'm bored, I mean bored into. White nostalgia in the age of the hipster bar is a dense sulfuric stink. For one reason or another, I keep inhaling. I order a pizza and neat whiskeys.

·

We are introduced to a blonde, and the movie seems likely to center her. She is stalked and attacked, but her blondeness and surplus lines of dialogue are supposed to save her. She dies around twelve minutes in, murdered in the goriest way. The gory murder of a blonde who spoke frequently suggests that no one is safe. Craven's *Scream*, credited with revitalizing the slasher subgenre in 1996, follows a false-protagonist formula he'd previously deployed in *A Nightmare on Elm Street*, a tradition traceable to John Moxey's *The City of the Dead* and Hitchcock's *Psycho*.

On nights when I want to slip inside the human space between guaranteed discomfort and the foreknowledge of it, I turn on the movie just to watch this paradigmatic opening scene. The killing of Casey Becker in *Scream* was momentous. It marked the end of Craven's hiatus from big box-office horror. It marked Drew Barrymore's return to prominence. It established the Ghostface Killer—that easily laughable horror symbol— as a significant addition to the lineage of slasher killers. It brought the Michael Myers tradition back to the unsuspecting suburbs, where high school girls are often home alone and anyone, especially their boyfriends, could be the home-invading butcher. It's as if, in imaginary Smalltown, USA, few other perils exist.

The killing of Casey Becker was historic. It's difficult to see the scene— her body disemboweled, dragged, and hanged from a large tree with the

rope of a swing—as existing outside of American history, as created anywhere but in the continuum of a societal id that can't forget what it's seen its own hands do, that merely shuffles the puzzle pieces of memory.

There being no Black main characters in *Scream* and so few in its contemporaries illustrates a dissonance, the rasp of unintended admission. These films imagine the extremities of white cultural depravity and brutality but do so in an America where only whiteness factors (and is in fact not "white" but some agreed-upon glare of homogeneity convinced of its comfort). This arrangement falls back quickly on psychosis-as-motive, in which the mysteries of mental illness and individual deviance are alibis for the whites-only fantasy. The artifice of chance is the drama. In the case of *Scream*, the logic seems presented like so: "These two white teens are psychological anomalies *and* their killing spree of other white teens is an isolated incident *although* all of their parents are always circumstantially absent *and* there will be a sequel in which another white person terrorizes the very same white people . . ."

•

I was a queer and skinny child whose dominant emotion was fear. Other boys practiced displays of power, thrashing and breaking their bodies in hours of commune. I hung back and cultivated a knowledge of exits, of how to get out alive, how to avoid entry. I was probably sitting on the floor, legs in a bow, safe from my cousins' game of tackle football in the front yard, when my aunt and uncle put a rented vhs copy of *Scream* in the vcr.

When I was a fifth- or sixth-grader in after-school care, my mother had an hbo subscription and I had a habit of unwrapping the aluminum foil from the school's afternoon snacks, folding and shaping it into a hook circa the fisherman of *I Know What You Did Last Summer*, and smuggling the flimsy prop out of the cafeteria and onto the playground, where I

stalked my classmates throughout the plastic fort.[2] I daydreamed of drafting a horror novel but only got as far as the cover image. I filled sketchbooks with color-penciled movie posters for teen slashers that existed and some that I hoped soon would. My drawings were decent. My depiction of the newly constructed playground had graced the school yearbook cover. One of my tornado scenes, inspired by Jan de Bont's 1996 special-effects montage *Twister,* had aired on the morning news. In third grade, my post-*Titanic* sketches of nude women had stirred some quiet controversy among the faculty, but in the end the principal was lenient, even impressed, having found the renderings "tasteful." I managed to keep the slasher sketches to myself until middle school, when all the low-boiling parts of me wanted to be acted out. My crosshatched knives stabbed no bodies but hovered in white space, dripping potential.

·

I'm a queer and skinny adult whose flesh has known more blades than fists, who once familiarized himself with the MOS of Bundy, Dahmer, Gacy, Ramirez, and others, and who is still a bit bolstered by being able to stomach certain information without a cringe.

One study offers that Black people are believed to feel pain to a lesser degree than whites. Another supports the existence of racial PTSD. Another: the physiological effects of racism can substantially shorten a life. What Black bodies probably know: you can spend a long lifetime performing the role of a retort, a punch line. I want to make of this an if-then statement, a colored optimism. My poetry students are optimistic about clichés. They hypothesize that *if* an artist acknowledges the cliché and/or transforms it just enough, *then* an audience can more readily accept the cliché.

2. *I Know What You Did Last Summer,* directed by Jim Gillespie (1997; Columbia Pictures).

In 1997, singer Brandy played the lead role in Rodgers & Hammerstein's *Cinderella*. The cast—portraying mixed-race families, royal and common— still perplexes people on IMDB message boards. The year after, Brandy was Karla Wilson in *I Still Know What You Did Last Summer*, a sequel for which the filmmakers seem to have taken a cue from *Scream 2* and included Black characters in the supporting cast *and* allowed them to survive more than half the action.[3]

Scream 2 cast Omar Epps, Jada Pinkett, Elise Neal, and Duane Martin. In the first minute, Pinkett's Maureen delivers the line: "All I'm saying is the horror genre's historical for excluding the African American element," and the sequel laughs loudly at its predecessor. Epps's Phil jokes about "an all-Black movie," and Craven, with writer Kevin Williamson's help, maybe giggles a little at himself. (His directing credit immediately preceding *Scream* had been *Vampire in Brooklyn*, which boasted a predominantly Black cast and raked in less than a seventh of *Scream*'s worldwide box office.[4]) Martin's character Joel, a comic relief, is the only one of the four who survives *Scream 2;* the others suffer together a total of at least thirteen stab wounds, Phil and Maureen having been targeted, it turns out, because their names loosely replicated those of white characters killed in the original *Scream*.

Karla Wilson is the best college friend of *Last Summer* veteran Julie James (Jennifer Love Hewitt). Julie runs a lot but lives again, as does her boyfriend Ray (Freddie Prinze Jr.). Unlike her boyfriend Tyrell (Mekhi Phifer), Karla—having fallen backward through the glass ceiling of a bedroom, having fallen backward through the glass roof of a greenhouse, having fallen backward through a glass door and played dead—also lives, limping into the penultimate scene.

3. *I Still Know What You Did Last Summer*, directed by Danny Cannon (1998; Columbia Pictures).

4. "*Vampire in Brooklyn* (1995)." *The Numbers*, Nash Information Services, LLC, accessed January 3, 2023, https://www.the-numbers.com/movie/Vampire-in-Brooklyn#tab =summary.

•

My granny didn't talk much; she didn't have teeth, and her jaws mostly moved to chew tobacco. But everybody seated in the shade of her apple tree shut up when she did have something to say. When she caught wind that I hung out with white girls, I was surprised by the unusual abundance of words she was sharing with me. I don't know what all she saw in her long lifetime, but I can assume from the quiet gravity of her warning that she figured her great-grandbaby was on a path to calamity.

A consistent drama of horror seems to be its nestling inside the trope of preying on and violating innocence, which is the domain ruled by young white women; or, young white women are compliant wards there. I wonder if Uncle Craig was somebody's Black friend, or if I should mention that Aunt Deborah could pass as white.

In her poem "The Jailor," Sylvia Plath writes *He has been burning me with cigarettes, / Pretending I am a negress with pink paws. / I am myself. That is not enough.*[5] I hold these lines like a grudge. Plath's speaker wants to level an indictment against the shadowy man who has imprisoned, abused, *drugged and raped* her. A numeration of injustices. To be burned with cigarettes— *what holes this papery day is already full of!*—is apparently a violence that a Black woman traditionally vests. Unambiguously, "paws" belong to an animal. *I am myself,* as if the rapist's imagining the inhuman Black in the speaker's stead lubricates his brutality. He is deluded, unappeasable. The poem swells with the desperation of this moment. *I am myself.* For whom is that not enough?

•

Gladiator death matches, Crusades, the Inquisition, the evolution of legal public execution including lynching, from the advent of television into continuously looped video clips of police shootings—all as though there's

5. From *Ariel: The Restored Edition* (New York: Harper Perennial, 2004), pp. 23.

a consistent desire to access carnage from the safe distance of a specta-
tor. Less than a century out of Jim Crow, I doubt it's difficult to argue
that a public imagination lingers with the same appetite for gore that
lynchings—their rape, dragging, shooting, castration, hanging, burning,
and displayed decay—once sated. Now it leeches elsewhere.

The physical kill. The imaginary kill. The execution that is "nigger." The
amateur porn subgenre of race-play. I tell a friend, *No, I won't let a man
call me that, fucking or not,* but I've watched a Black man enjoy exactly
this somewhere on MyVidster, threefourfive times now. When the white
boys slap the hog-tied Rogan Hardy and call him "nigger," their jaws
glitch over the strange shape of the word, their faces momentarily fun-
housed away from human, the eyelids receding, whites waxing cartoon-
ish. I watch, and a heated radius expands. I've been sweating the matters
of agency and impulse. My friend says, *But it's fantasy*—which it is, for
everyone except the actors: the man whose mouth makes the killing and
the one whose body approximates a corpse. But, I concede, even for them.

•

"What white people have to do is try to find out in their own hearts why
it was necessary to have the nigger in the first place." James Baldwin poses
this challenge on a PBS segment of Henry Morgenthau III's "The Negro
and the American Promise" in 1963. "Cause I'm not a nigger," he contin-
ues. "I'm a man. But if you think I'm a nigger, it means you need it."

In chapter 7 ("Black Is Back!") of *Horror Noire: Blacks in American Horror
Films from the 1890s to Present,* Robin R. Means Coleman analyzes Craven's
1991 cult favorite *The People Under the Stairs,* "in which the 'hood and the
suburbs stood in confrontation against each other . . . with the 'hood
proving victorious." She writes of the white slumlords in the film:

> The couple, then, represent a bundle of horrible taboos: (1) food
> (forced cannibalism); (2) death (they murder the two thieves); and
> (3) incest (among themselves and with their "daughters"). Central to

the narrative of their taboos is that these are horrors easily hidden behind wealth and Whiteness; two positions of power which mean one would seldom be suspected of, or can get a pass for, evil.[6]

Coleman has, by this point in the chapter, already made legible a few ills of *Candyman*, a supernatural slasher that is perhaps more candid about its leaning on the myth of Black monstrosity than it means to be, practically in syzygy with *King Kong* and, Coleman argues, *The Birth of a Nation*.[7] But *Candyman*'s eponymous hook-handed haint is only the Vader-mask to its messy racial mush-mouth.

The Candyman is the vengeful spirit of a lynched man, Daniel Robitaille, mutilated for his miscegenation. His bloody acts manifest his desire to seduce the live white Helen to her death. His trail of impoverished Black victims from the Cabrini-Green projects seems peripheral to this bizarre infatuation. Helen debuts as a (bored and scorned and) curious Chicago grad student. After hearing the legend of Candyman, she's taken in by a headline: "Cause of Death, What Killed Ruthie Jean? Life in the Projects." Her arrival in "the hood" from the highway's good side, looking for sources to inflate her thesis on urban legends, is cute and exploitative. What killed Ruthie Jean is more enigmatic and enticing than what usually kills the all-Black residents of Cabrini-Green, where, according to Helen and her friend Bernadette (Kasi Lemmons), every day a kid gets shot. Around seventeen minutes in:

BERNADETTE: I just want you to think, okay? The gangs hold this whole neighborhood hostage.

HELEN: Okay, let's just turn around then. Let's just go back and we can write a nice little boring thesis regurgitating all the usual crap about urban legends.

6. Coleman, *Horror Noire* (New York: Routledge, 2011), p. 191.
7. *Candyman*, directed by Bernard Rose (1992; TriStar Pictures); *King Kong*, directed by Merian C. Cooper and Ernest B. Schoedsack (1933; RKO Radio Pictures); *The Birth of a Nation*, directed by D. W. Griffith (1915; Epoch Producing Corporation).

The Candyman is a distraction. Décor. I fold him aside. Helen needs this haunting. Her whiteness and access to a predominantly white institution of higher education have failed to elude the risk of mediocrity. Whatever is lurking in the gutted Cabrini-Green projects, whatever killed Ruthie Jean, can save Helen from disappointing namelessness. In a stasis-intrusion model of plot, little dissimilates the intrusiveness of Candyman (who appears only to her) in Helen's high-story-condo life from Helen's intrusion into Cabrini-Green, where most of the blood in the film is shed—except that nobody seems to hallucinate Helen or the corpses made in her presence.

When I'm made to view the images of mobs huddled under hanged men, of Michael Brown's half-fetal body four hours facedown and cops at compass points, I wonder about necessity à la Baldwin. I think to ask, What do you need? Do you know? What did the landscape of Darlington, South Carolina, need with Craig's darkness? What does the urge toward mass murder need with anomalous madness? It seems that forms of atrocity have no use for the semantics of mental fitness. Darren Wilson claimed to have hallucinated a demon; he murdered a flesh-and-blood person.

•

One of the most insidious facets of Dylann Roof's massacre of the Mother Emanuel AME Church in Charleston, South Carolina, is the matter of setting. The Black church is a testament to and tomb of America's sustained racist violence, a memorial of pillage repaid in religion. Its insistence on the power of healing forgiveness is unwavering because what else. There is always something to forgive, to get over.

I was brought up in these places. My grandma can be found in one three or four days a week. Even on the phone she has a suffocating hopefulness. All that she survives she does so "by God's good grace." I'm still not irreverent enough to tell her that her God and our conditions are irreconcilable to me. I want to call more often. I wish she would just pray at home.

I'm anxious, ambivalent about the re-presentations of daily horrors—someone shot down, gun planted; someone pulled from car, their pregnant body slammed—because I neither trust America to live with its own memory nor trust myself not to forget to live. I mean I might try to forget in order to live. I might try. I'm often afraid. I'm not above trying.

There's a scene in *I Still Know What You Did Last Summer*, after a hurricane hits and the body pile first peaks, when Julie—who took this vacation in the Bahamas as a distraction from the murders of the previous year—finally reveals to her friends that they're all going to die and the who and the why.

> KARLA: How could you not tell me the whole story? I'm your best friend!
>
> JULIE: I just wanted it to be over. I didn't wanna involve anybody else.
>
> KARLA: Well, it's too late for that now.

They all stand in a downpour, distraught, on a boatless pier.

FOREMEANTIMEWORD: "PSEUDO-MORALS WORK REAL WELL ON THE TALK SHOWS FOR THE WEAK"

Alright. Gesture is gesture; and sarcasm, like satire, has its limits and expiration dates. Consider this my single content warning.

I despise the harm that Marilyn Manson has done to the people—and in particular, the women—who have trusted and even loved him. I cringe to think of the many fans who have had to scurry to reconfigure or refuse appreciation for his music in light of the allegations against him as a perpetrator of assault and intimate partner abuse, as well as the many who defiantly (often disdainfully toward survivors) "stand with him." I have chosen to believe the allegations, and to continue to consider *Mechanical Animals* a poignant and personally indelible American artwork.

But/And white people having a problem with how white (read: righteous, vaguely culpable, and hand-wringing) Marilyn Manson makes them feel—and their having a historical compulsion to create distance between themselves and their revelatory contradictions—is not a performance of innocence and act of self-deception that I have to participate in. They don't have a problem specific to Manson; they have problems. Therefore I've chosen not to impose retrospective intervention upon the content of the following essay, "Melancholia, Death Motion, and the Makings of Marilyn Manson," first published in 2018 (and originally written under the title "Devil in the Flesh"); I prefer it to be judged as it is. You are welcome to fast-forward and not read it. You are welcome to read it and to roundly condemn my perhaps flawed interpretations of his lyrics and burlesque antics. Fuck with it or don't.

I hope that you will, in the meantime, feel likewise welcome to dwell in the disconcerting possibility that anyone whose art you respect and thus subject to a critical eye (if you do such things) and—this especially—any person you happen to like (if you like people) has done objectively reproachable harm to someone else; and the additional possibility that they have done so *without* reflecting, in what they make or how they live,

an obsessive interest in violence or violation, moral ambiguity and contemptuousness, or outright presenting themself as a villainous metonym for an alienating, objectifying, exploitative, abusive materialist culture.

Fandom is an unnatural involvement (skip ahead to "*Blacula* still a cop film" for more on that, or choose your own adventure), and, like many people who've found their confusions clarified in the texts of someone with a platform and a bit of style, I've occasionally fallen for it. But please don't forgive me for having been young. I like to fancy myself a student of horror media. In doing so, I accept the risk that many lessons—often the ones with revisionary social implications—are accessible only from the position of my being in some way fucked up.

MELANCHOLIA, DEATH MOTION, AND THE MAKINGS OF MARILYN MANSON

"When you're a black metalhead, sometimes you have to let your inner junglebunny out." Growing up where I did—across the street from a Little League baseball complex in a border hood sitting on the city limits of one of the more commercial regions of the first state to secede the Union—there were times when words happened to me and, if I did not know them, I would look them up. This was not one of those times. I can honestly assume that, had I looked up *junglebunny*, I would have found a way to continue laughing with Daniel. I was fifteen or so, swathed in black—a Korn hoodie I wouldn't remove, construction boots, mock-bondage straps flailing like tentacles from shorts composed mostly of pockets, a regular walking Hot Topic ad of the early aughts—drunk for the first time, and dancing a hole into the floor. Daniel, my best high school friend, recorded the scene and then uploaded it to whichever social media platform most enthralled us at the time, along with the caption that I cannot forget.

This dance of my private primitive was the culmination of a party, and this party was, in a sense, an induction. On this night I met Shawn, Joe, and Will. We chugged our way through more Coors Light than I care to ever see again. We moshed to Slipknot and I spat every word of "Disasterpiece." I drank myself stupid. At some point I was invited to join Shawn, Joe, Will, and Daniel as one of "the Demons." I had nothing better to do, so I ate from a bowl of Cap'n Crunch Berries cereal floating in beer, threw up all over someone's bathroom floor and my own clothes, was showered naked in cold water from the hose in the yard, snorted jalapeño hot sauce off of a foam dinner plate, and was named a Demon. Clear of the crust of my own sick and curled inside the bracket of a love seat squeezed into a small bedroom, I spun into sleep. One of the Demons painted my face with a cherry popsicle. There is video of this too.

No, *induction* isn't quite right. The time I spent among them, mud bogging at the bottom of bulldozer dunes at the ends of dirt roads, hitting soda-bottle bongs in trailers on the edges of old farmland, and shaving our heads in the dry afterbuzz, now feels more voyeuristic than

native. These became regular weekend interludes, at the end of which I'd be returned to my all-Black home life. My mother and siblings and neighbors grew accustomed to white kids picking me up, and to the frequent appearance in our driveway of Daniel's red hair peeking through the windows of his shit-green sedan. We'd ride into the county to meet the others and pursue something closer to happiness. I considered them friends. I needed friends. I knew a kind of tenderness. I hurt abundantly and all the time, as they appeared to.

•

In 2017, my editor and I are wrapping up the copyedit stage ahead of publishing my first book of poems. Over a phone call we discuss the necessity of endnotes for such choices as my omission of an apostrophe from *aint* and my use of the word *paranoir*. The title of a track from Marilyn Manson's 2003 album *The Golden Age of Grotesque*, "Para-noir" is a word that Manson "manufactured . . . to represent excessive darkness and the paranoia of trust." In a poem, I repurposed the term to "signify a specifically Black anxiety of omnipresent antagonisms, if not also the whole person of the Black anxious." Between Manson's redundancy and my need to name a constant interiority, I feel, for the moment, more familiar with a paranoir mood than any other texture of paranoia. I began to know it best during my time with the Demons. I glimpsed its raw center whenever I got too high with white boys.

Within that concrete vortex sensation of being stoned—perhaps symptomatic of the way that time in that vortex moves—how the gap between my thinking of opening a door and my opening the door spiraled into self-fulfilling prophecy—a cataract over my reality thinned, shedded— here were the apparent anachronisms of the dirt roads: the repressed emptiness of fields, a bonfire and its orange glow against the trunks at the edge of the woods, the Confederate flag stretched across a window of the RV—that it wasn't *my* reality, that it belonged to something deeper, older, and until recently held at arm's length—that my friends are not my friends—their faces have changed, their brief ebullience at any form of entertainment—why is there a fire?—that any circumstance in this

landscape is malleable in their favor—who knows where I am?—whose faces?—am I a form of entertainment?—I feel the heat of the fire—who are they?—fire—who knew?—a fire.

Is being haunted like that? The voice in me, megaphoning my discomfort, squatted behind my stomach. Is intuition like that? I argued with it, didn't fully trust it while I mistrusted the people around me. I could never articulate this happening in a way that even I understood, so I frequently forced myself to sleep off the smoke. So many prescription medications interacted in me during that time that I was continually confused and induced to sleep. I preferred sleep. Waking was already grated with the problem of trust; such was living with unspeakable faggotry. But there was something in the thick of the high that I needed, and Daniel knew me well enough to not let folks fuck with me too much while I pursued it—unless it delighted him to do so himself, albeit gently.

I'd awake in the hot, aluminum-cannish RV, surrounded by posters for Twiztid and Insane Clown Posse. Joe would be slack-draped like a deflated windbreaker jacket next to me, watching hentai, pretending our feet were not touching. I'd awake on a couch in the squatter trailer in the same yard. Shawn's mom lived in a similar one in the lot, closer to the highway. I never saw her. I'd awake on the edge of a bed in which Shawn and Maggie were fucking, fully clothed and as quietly as possible. I'd pretend to wake up twenty minutes later. We would all plot to get some food from a nearby gas station, or we'd luckily uncover a couple of cans of ravioli and eat the goop cold because there were no cooking appliances in the trailer, or I'd be hungry until I got home wearing yesterday's clothes and the clay dust that our roguishness had lifted from the roads.

Once, in late summer, my mother dropped me off in another trailer park past the east end of town. The Demons were gathering at Shawn's older sister's place. There was a small fire. We sat in lawn chairs arranged in a circle around it and drank beer. When anyone shifted, the chairs' metal legs in their plastic brackets pushed dark divots into the bare gray dirt.

Shawn's dad arrived with a mild air of superstardom. I crushed on him. He wore a sleeveless tee, and beneath a cowboy hat his bald head was shaped like Shawn's shaven one except that the father's ears fit. A

cigarette's cherry glowed between his knuckles as the night darkened. He strummed an acoustic guitar and sang Poison's "Every Rose Has Its Thorn." Of course it had to be this song. He played it many times, or he played it once and the song seemed to last for hours. That not two hours previously Shawn's sister's boyfriend had introduced himself to me as the "Dutch Master" and tried to teach me how to roll a blunt in the trap-music-misted bedroom of their trailer had nearly slipped my mind. I hardly knew who Bret Michaels was then—and so didn't recognize how thoroughly Shawn's dad mimicked him, probably down to the buckle— but this cover saddened me. Everyone who heard it appeared mournful, or exposed, as though they had been in mourning all along—except for the man singing and playing the chords. It was almost as though there had been a dream in which Shawn's dad was someone else, someone famous like Bret Michaels but his own brand of heartbreaking, and his family could see that dream—I could see it, maybe, where the flames illuminated their faces: they were elsewhere, transported by the beer and the dope and the song, dreaming American.

I rolled my tongue around my cottonmouth, feeling unnecessarily intrusive. Ants toiled nonchalantly beneath us, accompanied by shadows triple their size. Overhead towered old trees shawled in ivy, and through their branches sailed the sounds of the nearby overpass. It was a highway that would, by one side road or another, take one to the Columns Plantation—a Civil War reenactment site that we visited as a field trip in the second grade. It occurred to me recently that my mother had to sign a permission slip for that. At home I heard the mantra "the South will rise again" in what I thought was the tone of humor, a way for my family to laugh off the ubiquity of the Confederacy's legacy. Until I was three years old, we had lived in a trailer park not far from this one, Momma and Daddy and me. Then Momma was pregnant and we moved into a two-bedroom house on the south side. We wore hand-me-downs and ate packaged goods for a long time. Aunties and play-cousins babysat. Momma moonlighted until she didn't need to. I don't know how it all looked from the outside. Ascent was meant to be exclusively in our future, not in our memory.

•

Smells Like Children, Marilyn Manson's 1995 remix EP that featured the soiled and enduring cover of Eurythmics' "Sweet Dreams (Are Made of This)," also featured a cover of Patti Smith's "Rock 'n' Roll Nigger." Recorded in the late 1970s, Smith's song, cowritten with bandmate Lenny Kaye, may best summarize itself in these lyrics:

> *Jimi Hendrix was a nigger.*
> *Jesus Christ and Grandma too.*
> *Jackson Pollock was a nigger.*
> *Nigger, nigger, nigger, nigger,*
> *nigger, nigger, nigger.*
> *Outside of society, they're waitin' for me.*
> *Outside of society, if you're looking,*
> *That's where you'll find me.*

For Smith and Kaye, Hendrix and Pollock (and Jesus and Grandma) were equally niggers in that they were, by this definition, social exiles—and admirably so, such that Smith in culmination takes up the mantle of the nigger, growling finally, "That's where you'll find me." *Nigger,* it would seem, is a place one can go and, by the same token, leave again.

More curious to me than Patti Smith's maladapting *nigger* into a hipster power anthem or, just now, how Manson's cover was complicated by his later artistry and behavior, is where my friends fell inside the echo of that same sentiment. They were between the ages of nine and twelve when Eric Harris and Dylan Klebold killed twelve schoolmates, one teacher, and themselves at Columbine High School.[1] They were in the disorienting vicinity of puberty and various panicked masculine postures in the jingoist aftermath of September 11, 2001. They were attempting to graduate high school at the dawn of the Great Recession. Shawn dropped out at least twice. Daniel had been keeping an after-school job at Domino's for as long as I'd known him. The universal affects of that time

1. With whom in mind Manson is alleged to have written "The Nobodies": Joseph Schafer, "The 10 Best Marilyn Manson Songs," *Stereogum*, April 8, 2015, https://www.stereogum.com/1792094/the-10-best-marilyn-manson-songs/lists/.

were anger and melancholy as our illusions of physical safety and social mobility unhinged and sagged toward the foundation.

I would eventually count three expulsions to my name. The first folks to get me high were Nirvana fans I met in alternative school; they seemed more certain than most that their being there was a hiatus. I had emailed the lyrics to Korn's "Thoughtless" to a white teacher who monitored my high school's halls in the mornings and who, in her blanket disdain, found me remarkably incorrigible; my future was a cloudy question but quickly becoming less so. I was most drawn to bands who, on one hand, appropriated the braggadocio of rap and laced it with horror and the aggression of hardcore, such that each band seemed in competition to disturb with the most swagger. On the other hand, while their lyrics consistently lacked acumen and left their specific anathemas behind frosted glass, these bands could aurally reconstitute terrains of pariahdom with such familiarity that the question often was, yes, how I found the company comforting within the architected abandon.

This music was a single boat moving over the blues. It was an inverted pop art print of Black Power militancy. It raised a carnival tent over my real Black, queer, depressive American coming of age, but where did that find Shawn and Joe and Daniel and Will? They were restless. They were offered seemingly unmitigated rage and the cadence of revolution. It all rang of disenchantment, but from what, exactly? They were Demons. They perhaps felt themselves in the limen of an underworld, their distance from grace probably the distance between what they were and what, in the fantasies of whiteness and manhood, they heard they should be. Nigger-ish, almost, maybe—who am I to disagree? Mainly, they were monstrous because they were yet undistorted where distortion is set as the standard. Demons, in that if they were going to resemble the shadows of their not-rock star fathers, they would—what, have gruesome agency in this failure? The question of *whose failure* amplifying the shrill and voluminous cacophony of heavy music as we knew it, but rarely focusing the genre's attention-deficit anger in the direction of a legitimate, sustained inquiry.

What happens to that momentum? Could the Richmond-based quintet Lamb of God have, in their multi-album critique of the "War on Terror,"

resisted the arrogant tug of reproducing marketable rancor for long enough to help helm an organized protest of US foreign policy? Could they have mobilized more than their notorious "wall of death" mosh pits? Maybe I'm naïve. Maybe they were. Predictable—in the way that the aging of all of my once "radical" "anti-establishment" "freak" friends into conservative, family-sanctifying pay-no-minds has become predictable—that the Lamb of God who offered

> *Your trust has been misplaced, believed the lies told to your face,*
> *Became another casualty and now it's too late.*
> *You finally made it home, draped in the flag that you fell for.*

and the unmistakable howl of

> *Now you've got something to die for,*
> *Infidel, Imperial.*

eventually succumbed to the bootstrap-tugging

> *And now is the moment where everything can change.*
> *You are completely responsible for your own life*
> *And no one is coming to save you from yourself.*
> *So stop blaming your problems*
> *On any and everything else.*
> *It does not matter one tiny fucking bit*
> *How unfair you think the world is. It's only what you do.*

And yet, everywhere I've looked, this is the narrative of sons of the American South—a landscape that is, to me, the clearest cautionary tale against forgetting that white people in this nation are not self-made by merit of hard work or integrity, or forgetting that whiteness is a project that dehumanizes even, and especially, themselves.

But they must forget it. Imagine: admitting that even your audacity to scream that nothing is right is based on your investment in the delusion that who you are is the one right thing—then admitting that that

one thing is a myth, beneath which blows the debris of what you've mutilated for the sake of your not-self, and knowing this bodily, holding in your veins the hell of it—and needing to put that knowledge somewhere. From here, I can see how much they would risk in digging, and yet I am hunted. In denial, they put their nothinghell in me.

•

This past Sunday, in Las Vegas, a sixty-four-year-old white man aimed semiautomatic rifles from his hotel room window and fired—at a recorded rate of nine rounds per second—into a concert festival crowd below, killing at least fifty-nine people and leaving hundreds injured.[2] On the night before, at the Hammerstein Ballroom in New York, in the third concert of the US leg of his *Heaven Upside Down* tour, Marilyn Manson performed the forthcoming album's first single, "We Know Where You Fucking Live,"

sang *Let's make something clear: we're all recording this as it happens,*

sang *Those diamond bullets, storefront blood banks, splinters, and stained glass,*

sang *Don't need to move a single prayer bone,*

chanted *So what's a nice place like this doing 'round people like us?*

chanted *I love the sound of shells hitting the ground. Man, I love the sound of shells hitting the ground. I love it.*

Two songs later, while performing "Sweet Dreams," rounding the serrated edge of the last "abused," he attempted to climb onto his stage

2. Larry Buchanan, "Nine Rounds a Second: How the Las Vegas Gunman Outfitted a Rifle to Fire Faster," *The New York Times*, October 5, 2017, https://www.nytimes.com /interactive/2017/10/02/us/vegas-guns.html

props—two giant pistols backdropped by blazing pink neon—which immediately collapsed on top of him, sending him out of the venue on a stretcher and resulting in nine canceled tour dates.

Manson's magical proximity to firearms massacres is, I know, not magical. His practice is prismatic, his lyrics a sieve. The sole-stuck gum wad that snatches a bit of every passing secret in the dirt, Manson is an infamously egotistical, reactive satirist / shock-pop peddler / cultural critic–cum–political incorrectness concentrator.[3] His public image (traditionally extended to his live band's) has previously incorporated sights and sounds of the Third Reich and its collapse while attracting the obsessive zeal of fanatic "family" groups across the country. His *Grotesk Burlesk*–era geometric blackface, likened to the head of a gimp suit and crowned by Mickey Mouse ears, evokes the ilk of such sexualized child pop stars as Britney Spears and Justin Timberlake. His "Cake and Sodomy" (and its remix "White Trash"), along with his Episcopalian upbringing in Canton, Ohio, and later education in South Florida, foreboded a portfolio of attempts to index white depravity, and to such extent that I think of poet Frank Bidart's "Herbert White."

The traces of Manson's body of work worm and settle into my writing—as did the smell of grease into jeans I daily wore to grill burgers in the late aughts, as mercury does in the mackerel, as obsession when it begins. If there is a Great White Artist of my generation—an artist, I mean, who best expresses the crisis of the white condition while maintaining an entertaining, multifaceted, severally indicting presentation; whose contributions one could justifiably magnify at the expense of other notable white artists of his era; an artistry possibly transcendental of whiteness; approaching, dare I say, the post-white—who better? Okay, I'm fuckin around, if you can't tell. But as I may be well on my way to becoming—by way of its being my persistent luggage—a connoisseur of

3. Manson's thesis or aesthetics statement to this degree, if he and his unstable list of co-composers could be said to have one, is probably most front-loaded in the lyrical litanies of the songs "Get Your Gunn" (1994, from *Portrait of an American Family*, Nothing/Interscope), "Irresponsible Hate Anthem," and "1996" (1996, from *Antichrist Superstar*, Nothing/Interscope).

the white condition, I think Manson has been curating a lyrical exhibition for the better part of twenty years:

We are the nobodies: wannabe somebodies. We're white and oh so hetero, and our sex is missionary. I fuck you because you're my nigger. Everybody's someone else's nigger. I know you are, so am I. You are what you beat. I'm not attached to your world. Yesterday, man, I was a nihilist. Now, today, I'm just a fuckin bore. You say you want a revolution, man, and I say that you're full of shit. Nothing heals. Nothing grows. My afternoon's remote control. Daydream milk and genocide. Slave never dreams to be free. Slave only dreams to be king. We're killing strangers. We sing the death song, kids, because we've got no future, and we wanna be just like you. You were automatic and as hollow as the o in god. Do you love your guns? god? government? I wanna thank you, Mom—I wanna thank you, Dad—for bringing this fucking world to a bitter end. It's a great big white world, and we are drained of our colors. We're killing strangers so we don't kill the ones that we love. We used to love ourselves. We used to love one another. In a world so white, what else could I say?[4]

What's to say? I wonder, while watching the music video for Manson's 2001 cover of Soft Cell's eighties hit, "Tainted Love." Soft Cell's version was itself a cover of a 1964 record by Gloria Jones. Though Ed Cobb wrote "Tainted Love," Jones herself wrote songs for Motown groups including the Commodores, the Supremes, the Jackson 5, Gladys Knight and the Pips, and others. Manson's music video was directed by Philip G. Atwell, whose cv largely boasts Eminem music videos between 1999 and 2005 (not including the video for "The Way I Am," in which Manson features)

4. Lyrics here are collaged from, in order, the following Marilyn Manson tracks: "The Nobodies," "I Don't Like the Drugs (But the Drugs Like Me)," "Para-noir," "Irresponsible Hate Anthem," "Great Big White World," "I Want to Disappear," "Disposable Teens," "Snake Eyes and Sissies," "Slave Only Dreams to Be King" "Killing Strangers," "The Death Song," "Mechanical Animals," and "The Love Song." Certainly this is a reductive representation of a career spanning ten albums (as of 2017), convoluted conceptual conceits, and a revolving door of collaborators, but in the spirit of *race*, I'm momentarily playing the role of gatekeeper; ergo, an obligatory abridgment and a sacrifice of nuance.

and includes 50 Cent's "In Da Club," videos by Dre and Snoop, and—a personal favorite—Truth Hurts's "Addictive," featuring Rakim. There spins a queer galaxy of Black art, and askew in its orbit—as are most American pop culture products—is this video, which extends the derivative conceit of the film it supports.

The soundtrack for *Not Another Teen Movie* comprised rock covers of new wave songs almost entirely, while the film amalgamated a parody of over a dozen popular films that centered the lives of white teenagers and their concise social compartments—a spoof of spoofs. To fold Manson into such a project is obvious. In the music video, Manson pulls up in a pimped '69 Lincoln Continental vanity-plated "Goth Thug," grinning a mouth full of fronts, to crash "not another high school party" with a posse of cable-ready rockers. An extra's maimed tank top reads AIN'T NUTHIN' BUT A GOTH THING. In his commentary on MTV's *Making the Video*, Manson describes the concept as "a sort of vanilla crowd and a darker element coming and ruining the party."

•

Back in high school, before I "knew better," I was attempting to know something. And what interests me about gaining this kind of knowledge—what I earlier called voyeurism—is that I did not need to pursue it. Because I am colonized, my function is to learn the desires of white men if I am meant to learn anything at all, and so that education comes like sustenance to me, although I cannot, *cannot* eat it to live. But also—and maybe I shouldn't write this thing—there's a strange (although brief, flighty) relief in being gazed upon, covered in the myth that is the Black: they assume they know me; with the empathy by which they swear, they put their colorlessness beneath a black mask and blink out of it; and in this assumption, while having no historic allegiance to the power of mystery, what they love and what they hate, what pretends to love but hates them truly, they tell it. They tell it to my veil.

Of what any of the Demons had, I wanted nothing but their gall—which would seem misplaced, vestigial, considering that they had in them and between them so much shame. (I'm not even using their real names.)

The way that Daniel's face winked and shined like a boxing glove as he recounted to me how he and his girlfriend fucked atop the felt skin of a pool table, and the sound it made, and the fluid she left on his boxers; or how Shawn would speed his motorbike onto any land, repercussions be damned, because his dad knew some tenant or his grandma used to own a plot or why-the-fuck-not; or how easily, perhaps eagerly, Will drank himself toward dangerous belligerence; or how they made unquiet commerce of the same women; or how they called a boy we knew "the faggot" as though that were his name, as though his actual name were insufficient, as though his having a name at all were a surprise—it all reads like the story of freedom, is not freedom, is not disregard but rather a particular incognizance of limitation or of culpability, is skin-to-pit belief in where they stood in some unspoken hierarchy.

They believe it for their lives. Nothing is supposed to happen to them. They do not grow up. They live to replicate the world into which, slick and screaming, they arrived. Even their rebellion is always the legend of reclamation. They are entitled to a place in the world, to a tier or a stable footing, to the right to take it back from whatever they imagine would invade and change the landscape. They terrify themselves into themselves. They do not move on. They do not attempt to repair what what they've done has done to them. They do not get over. *Nothing heals.* They aspire to forefatherhood. *Nothing grows.* They want the end of the world, and then they want kids. They return to core values. They do not grow up. *We've got no future.* What is this compulsion—this motion—but death? They turn back. The salt of the earth. They turn like knives in the soil. Some of them would read this and recite, "Not me." They are different, exceptional. Nothing is supposed to happen to them.

I haven't spoken to Daniel in several years, but Momma occasionally asks about him and the "Branch Road boys." From this side of his Facebook page, it looks like he still attends a lot of rock concerts. He got married in a church; they wore their white and black. There's a child, maybe one on the way. With a link illustrated by a photograph of young Black people jumping on a police car, he's shared a Change.org petition to "make rioting a political hate crime."

Someone could speak to Daniel, but that's none of my business. It's the spring of 2018. I have tickets to see Marilyn Manson and Rob Zombie on their *Twins of Evil* tour in July. I have fewer illusions about evil. What I've loved hasn't always served me. I'll see the scatter of other Black people in the crowd and wonder only somewhat about what they've laughed off. I have a habit of pretending not to know a thing, but I'm unlearning that. When I permit myself to visit the South, some sensations rise across my body that you wouldn't believe. Some times to be known is tender, abundant hurt. Secret joy. My mother, who feels the need to adjust her mental chemistry with prescription antidepressants in order to manage under white supervisors until retirement—she pretends not to know a harm. My tenderest debt. This country happens to people and owes the most.

CARRY ON, WAYWARD SON.

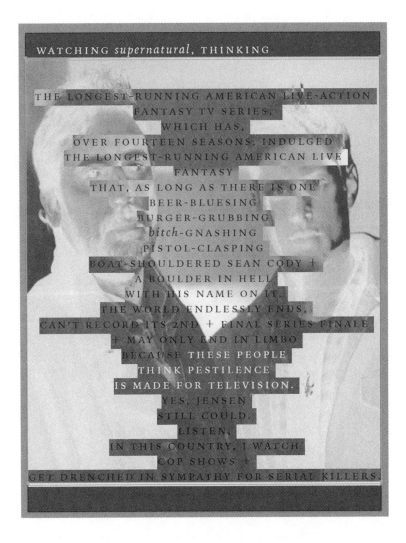

WATCHING *supernatural*, THINKING

THE LONGEST-RUNNING AMERICAN LIVE-ACTION
FANTASY TV SERIES,
WHICH HAS,
OVER FOURTEEN SEASONS, INDULGED
THE LONGEST-RUNNING AMERICAN LIVE
FANTASY
THAT, AS LONG AS THERE IS ONE
BEER-BLUESING
BURGER-GRUBBING
bitch-GNASHING
PISTOL-CLASPING
BOAT-SHOULDERED SEAN CODY +
A BOULDER IN HELL
WITH HIS NAME ON IT,
THE WORLD ENDLESSLY ENDS,
CAN'T RECORD ITS 2ND + FINAL SERIES FINALE
+ MAY ONLY END IN LIMBO
BECAUSE THESE PEOPLE
THINK PESTILENCE
IS MADE FOR TELEVISION.
YES, JENSEN
STILL COULD.
LISTEN,
IN THIS COUNTRY, I WATCH
COP SHOWS +
GET DRENCHED IN SYMPATHY FOR SERIAL KILLERS.

A friend recently exposed me to the original meaning of the verb *purchase:* "to pursue." Its other definitions, out from under the register of cash, include "to exert oneself to achieve an object or attain a goal" and "to haul up or draw in (a rope, cable, anchor, etc.) . . . to hoist or raise (anything) with aid of a mechanical power," and, as a noun, it denotes a firm grip and an exercisable power or advantage.[1] My wish to apprehend *purchase*'s flirtation with apprehension is now spiritedly closing (in) on two scenes in Brian De Palma's *Carrie*, seconds apart in sequence. Two circles. Two shapes a purchase hopes not to be.

These circles are about presence—about company, or accompaniment, or companionship, hyperbolically. These circles are blatant lies, and they are also clearly, devotedly believed; therefore, they are among the most cinematic moments in the film.

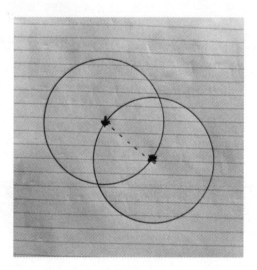

1. "Purchase, v.," OED Online, Oxford University Press, accessed December 20, 2022, https://www.oed.com/view/Entry/154832?result=2&rskey=1htY3g&. "Purchase, n.," OED Online, Oxford University Press, accessed December 20, 2022, https://www.oed.com/view/Entry/15483.

Belief is not a circle's prerequisite. In this way, it isn't like a line, which needs one event to be convinced of its relation to another. The circle—which I'm inclined to also call an *environs*—preexists the line. Each thing centers its surrounds, indistinct and unmarked until approached, encroached—*purchased*, I suppose—by another central thing. This is the solace of our social distance, and the solicitation of our fucking: *I am in line to disrupt your surrounds,* but of what surrounds can I have believed myself the center without you to challenge or confirm the radius?

This was the human sadness of God, I forget. And my line of attention strikes it (God) like the belled rim of a tambourine. If the sound of this is bullshit, it's because I'm drawing a line.

No center without you. In the first circle, I find Carrie White and Tommy Ross: pink and blue, blonde and blond, bewitched and washed out by the lights of prom, in "Love Among the Stars," where they become the contrived focus of an environs of artifice utterly. The camera is a line of attention, a proxy for my presence, but it operates now in pretense; it tells the lie of the absence of my eyeline of relation. It masks my simultaneous event. My concurrent center.

The camera pans as though innocuous to—but not independent of—Carrie and Tommy. It pans counterclockwise, as if to insinuate the dream of their timelessness, driving against eventuality, against *the* event: the end of the music, the resumption of the line of the last night of their lives. This dream can't be dreamt in the awareness of an audience, and that is why the camera cannot give me away. It must chain dance from a low and adoring angle. It must not look either of them in the eye. It must not *be* an eye, but rather a reflection of the couple's luminosity, blinded by them and reflecting their blindness.

Sly behind this camera that pretends it is not a camera, we can persuade Carrie and Tommy that they are safe from plot, safe from lines and levers, from effort and firm grips on rope. And under artificial stars, in artificial colors, artificially in each other's company, they believe.

This is violent: this conspiratorial excess of expression on the part of the cinematic art. Its refusal to let the two in on the joke; its dazzling, dizzying rhyme's pre-punctuated all-fall-down loves to know something they don't. It sleazes false leisure. I, viewer, am a center they don't suspect. They don't consent.

Meanwhile, Margaret White is pacing a second circle around her kitchen table. The camera, immobile above her, observes from a humiliating angle this intermission of her faith. (Humiliation is the human smallness of God, I remember.) Plotted in a line, looking back through the camera's dependent and doting relation to Carrie and Tommy, this iteration of accompaniment is self-centered. It is unyielding. Margaret revolves, wavering in the light of its attention, not always in the frame. That is, the violence of this vantage remains whether or not she holds herself—and her daughter, her damnation—firmly to its strictures. Camera Pantocrator.

I am a rigid witness, a juror, and I am the extension of her manic contemplation. I shine down like a wedge in her mind. String of her spine. Lamp on a chain, hatches across the linoleum floor, shadow of wall sharp upon the door: here is the dominion of the straight-line stitch.

Mother is a circle, a motion of return. Margaret's God is not a mother. He is an arrow.

The camera single-tracks the psychologist's proximity to her doom. The hues are blue, the inmates uniformed. Seven gates and two swinging steel doors semicolon the distance between Miranda and her preoccupation, Chloe, who is being overfed sedatives. Chloe's "embellishing" her rape story. To Miranda, the distance seems far.

In this horror, the men are believable. They are the arbiters of belief. The phallologicians. They tend to correct; correction is tenderness, is a courtesy: "There was no girl." "She died four years ago." "You killed Doug." "We are your family now." "You're in crisis." "This image is tailor made for your mind." "You better start thinking of some answers." "Delusions." "Hallucinations." "Frequent derailment." "Incoherence." "I have to tell you something very difficult," the film says in the direction of someone who seems not to know. "How do you know it was the Devil?"

The first ghost is possession itself. Every night, a man arrives anonymous and, without a trace, takes what he wants from Chloe. No, the trace is on Chloe's face; they say she did it to herself. Chloe is Miranda's patient. Another man wants to fuck Miranda, but Miranda is his boss's wife. "Until then she's mine," another man bites into a telephone: he's the boss, Doug; Miranda is his wife; Chloe is his ward; he's the chief of medicine; he's a doctor discussing a prisoner; the prisoners all are women. He rejects a lawyer's transfer request, then instructs Miranda to throw water on a mirror, inviting her to participate in metaphor. I have to tell you something, says the film. She calls herself the mirror; Doug calls himself God. God is married to a mirror, the film offers, as God prods her mouth with tongue then leaves to strangle a white girl chained in the basement of a farmhouse they own. He shares this weekend recreation with his best friend the sheriff, who is white and possesses this closet of God. God and the sheriff kill women together.

Miranda metaphors herself secure: this is a prison; it operates in frames; she, in observations. It is safe to swim during a lightning storm. All the

other doctors are men, if you can believe it. Chloe is embellishing her rape story again.

The second ghost is surveillance. The ultimate dom, it determines the motions of everyone. There is the white girl that Miranda sees attacking her, and then there is the nobody-but-Miranda that the CCTV sees tossing her own body from wall to wall of her cell. "There was no girl." The sheriff and Doug show love to each other through exchanging video of what they do, which determines what sense Miranda can make of what she and an axe have done to Doug. The video determines that there was indeed a girl. Many girls.

The white-girl ghost achieves in her deathly restlessness a certain omniscience. She watches from within glass surfaces, leaves the message NOT ALONE in breath and blood and Miranda's skin, knows exactly where and to whom what happened to her is happening now. If Miranda, possessed and detained, can abide the harm the ghost inflicts upon her, she'll come to this knowledge also. As recompense for her ignorant complicity in the husband's murder spree, she'll have to see herself dismember him, live and screaming; she'll have to work hard toward the other side of detention. The dead white girl can open a prison door, but Miranda must swing the axe. The distance expands and contracts.

A camera carves into space what an overtiming prose writer at a mic makes of detail: I have to tell you something else that I've been giving my attention. "You can't trust someone who thinks you're crazy." Chloe defines double consciousness for Miranda. "You are not a doctor in here, and even if you tell the truth, no one will listen." The camera pans in the design of Miranda's spiraling. The camera
has a man's hand on it, a man's hand
in the script in her mouth. Miranda says
"I'm dreaming" nine times in twenty-one seconds:
every three seconds she fails to correct
her reality. She slaughtered
the husband. She bathed in his blood.

In the mirror the white girl jumped out.
The white girl's vengeance put Miranda in cells;
what the men believe keeps her there.
The sheriff tries to kill her in the jail;
these cops are life sized. This horror
is water on a mirror. The film
is a frame from the edge of which men
whisper in their observations,
their collaged and ineloquent synopsis;
it culminates in conjunctions of gas and light.
The men must be believed when they tell you
something you seem not to know.

My problem is, for all my wet-hot sniffing after existence as a different crea-
ture, I'm still some kind of man. I expect life-altering phenomena to present
as brief explosions of epiphany, violent outbursts of correction, righteous
killer instinct erupting from my chest. Revolution, not just now but imme-
diately and impermanently. Acts of rebellion as gory assassinations of politi-
cians, plutocrats held for ransom. Here is Charles Dutton's grimace, going,
Nobody never gave me nothin!—just as American as it wants to be, as I am,
not wishing to admit that everything I imagine was imagined for me.

My dread should be similarly ejaculatory: exhausting and removable.
Therefore I don't know what to make of this music, of the one swollen note
held and mutating 20th Century Fox's regal fanfare into elastic hopeless-
ness. The opening of *Alien³* is dread's declaring the rolling hills of its sover-
eignty, its stamina of suck. Shots of blood, fire, and digitally scanned body
violation bisect the list of men whose names, mounted in deep space, need
punctual credit for their creativity: SCREENPLAY BY DAVID GILER & WALTER
HILL AND LARRY FERGUSON. DIRECTED BY DAVID FINCHER. In case it wasn't
clear, let the onboard computer be the first to tell me: STASIS INTERRUPTED.

I come into this thinking I know everything. I know how a quadrant of
planet convinces me of its innocence when a terrible vessel breaks across its
luminous curvature. I know that the jettisoned, crash-landed pod contains
one live human adult, one dead human child, one defective android, one
dead human adult, two xenomorph embryos, and hitherto all of my narra-
tive attachments. I know that Lieutenant Ellen Ripley—twice a final girl by
now; what, in the eighties, Carol J. Clover determined "a male surrogate in
things oedipal, a homoerotic stand-in, the audience incorporate"—is a gen-
der trouble.[1] And as the audience, I think I know Ripley's story: she fights,
survives, and loses a child, then fights, survives, and loses a child and, by
the end of this film, dies giving birth to the parasitic offspring of her neme-
sis, her predator and prey, her erotic counterpart. It appears to be this way

1. Clover, "Her Body, Himself: Gender in the Slasher Film," *Representations*, No. 20,
Special Issue: Misogyny, Misandry, and Misanthropy (1987): 213, http://www.jstor.org
/stable/2928507.

with nemeses. With narrative. With the Moirai and their yarns. With white men's authoring white women and some protrusion in/of the dark. With Black people and the prison industrial complex. It would appear.

When Clemens, a sensitive and lipless medical officer, lifts Ripley Lois Lane–style from the wreckage, the residue of work saturates her. And why shouldn't even she—"[science fiction] cinema's paradigmatic proto-feminist"—look like the levels of hell she descends?[2] She's fallen a long way from the bright white cotton of the first film, its single alien, the gulps of vacuum-sealed shuttle air between her goose bumps and its crevice-packing, salivating; what simple, timeless threat. Now, in under-wear the color of mourning and ineradicable creatures and space, she awakens to penetration—Clemens's needle.

Ripley, hitherto physically invulnerable, has a fucked-up left eye. Hitherto impermeable, she unknowingly incubates an alien queen—the reversal of all her previous duress, her negation—and then fucks Clemens, officially abdicating, by horror law, her final girl status. "I hate to be repetitious about such a sensitive subject," Clemens says. Sex with Ripley isn't merely transactional: it damns him too. There is a dark, evasive fatality slipping through the tubes again. There are incarcerated men who have been reborn in the bosom of God and not since tempted by a weakness of the flesh. Clemens's allegiance would have been more to Ripley's person than to her body, which must be allied to the alien and in service to the unborn queen. For the sake of tension and stamina, he's the kind of company she can't keep. The inmates are a company kept to itself, a stasis interrupted by Ripley's arrival. The Company proper, Ripley's abusive, obsessive former employer, keeps coming.

Previous films in the franchise ask, Don't you too, viewer, feel both isolated and targeted? But this film follows every living being in the vicinity except the head lice. It says, Viewer, your vulnerability is as tenable as these zealous, oily, convicted rapists and murderers are relatable, given

2. Adilifu Nama, *Black Space: Imagining Race in Science Fiction Film* (Austin: University of Texas Press, 2008), 110.

two scenes of vapid characterization. A distant world of empathy from what *Aliens* demanded for US marines. Viewer, part of me always resents *Aliens* for that.

The year is 2179 CE. Private prisons not only continue to exist but also occupy derelict planets in the galaxy's "outer veil." The inmates of Fury 161 are what simmers in the soup of desolation, risk, and underpaid labor. Surely, the homosocial breeds misogyny, xenophobia, and extremism— which is too bad because Ripley goes everywhere in the universe alone, and this prison is no different. The prisoners consider "the presence of any outsider, especially a woman, a violation of the harmony." They "forge lead sheets for toxic waste containers." They are the twenty-second-century civilization's most abject discards, creating from one of its most toxic resources vessels for its most abject discards. Who am I to refuse them their hate, their want to protect absolutely whatever delicate homeostasis still affords them individual character, familiarity to each other, someone-ness among the twenty-five people that our capitalist descendants have marooned in the galactic fringe, far removed from any iota of liberal sentiment?

The trouble at the limits of this empathy is that I would have read-ily accepted a hate-fuck from 1992's Holt McCallany. "The target is . . . our witnessing body," writes Clover of the aim of horror cinema, of slashers in particular. "But *what* we witness is also the body, another's body, in experience: the body in sex and the body in threat."[3] Beyond both of these, I think, is the body raped. What I'm supposed to feel, wit-nessing Ripley bent over a rail, jumpsuit-to-jumpsuit with McCallany's Junior, is the opposite of want; something like disgust, which I do feel, but feel toward myself, and not in equal amount. What I feel isn't the limit of vicarious experience as a cinematic ambition, neces-sarily, but rather the inevitable "use of her as a vehicle for [my] own sadomasochistic fantasies."[4] No other moment of the film so calls my

3. Clover, "Her Body, Himself," 189.
4. Clover, "Her Body, Himself," 214. Here, Clover wonders if the final girl, exempli-fied by Ripley, is not at all a feminist construct (despite typical celebration to the con-trary) but rather a contrivance of phallic exercise in the "wholly masculine discourse" of the slasher film.

body forward. Certainly not the Black man rushing forward to rescue Ripley from this particular destruction. It is a sensitive subject.

There are people who say such romantic things about vulnerability and beauty that let me know no one ever beat it out of them only to beat it out of them again on Tuesday and Wednesday. They, who would infantilize me—bless my heart—and my use of performance and secrecy to survive, think that the synonymy of performance and survival has phased out of function. They've been through all they've been through in order to say whatever they wish about compassion, how I must lack it to think *humanity* is an archaic pejorative. My suffering is millennial and precedented, so I fail to surprise them by acknowledging this: once, it was determined that I was not a "well-rounded" child, and in their subsequent effort to correct my oblong deviation, people whom I trusted to accompany me in mutual desire for my life almost ended it. How maudlin is this. I can tell these are the kind of people who believe in tough love and constant reflexive condescension because they can be forgiven for being flawed. They remind me of someone who tried, in many ways, to make revision the same as unconditional love for a young person, and now prays every Sunday for redemption. I mean the paternalism looks knee-jerk on them. They cannot fathom that, in our fight forever and a day to be freely ourselves, some of us might be the casualties. A child as not even a sequel but a remake. No, their voices don't break that way. Their necks cut through a room like they can't be choked out. They aren't gullible; they've never believed a word said about them.

Redemption comes, too, to Ripley's attempted rapist, who baits the alien into a cell and, once the doors seal behind them, screams as the caged beast rips him to drenched strips. The fires outside the cell diminish in slow motion. A "woman vocalizing," violins, swan song from an oboe. Dead, Junior is any man: he died doing a good, or merely died, and his evils evaporate in what aspires to be beautiful.

AFTER *THE FIRST PURGE* AND IN THE PANDEMIC
I HAD TO START LOOKING AT PEOPLE FOR REAL

A question is whether Kendrick's "Alright" is/was its own moment or rather a cue for many moments of one predominant kind. The praise break, for instance.

Moment into which you can be unindividuated as any single serif in the paragraph, provided you keep moving.

Moment you don't need to know all the words for and would be forgiven for making up your own.

A moment nonetheless you are presumed enthused to participate in no matter what music it's known you'd rather have move you.

Because the mo(ve)ment doesn't appear to be about Kendrick as a mover, just as the spirit is not your great-great-grandmother's slaver's god—though it matters as much in either case who is absent and not invited to be touched in its midst. In the communal mo(ve)ment, a contract is drawn toward the conditions of ecstasy. Its terms are, roughly:

I come in. I carry experience in the flesh like a water cone filled to the
lip, and then I begin to sway. We each get in the sway til all us shake,
experience spilling over and out of and over into. You could be thus
emptied of what you come in here with, or I could help you carry it.

I think that to misperceive this mess of experience, this wet destress, as a fluid exchange of struggle, strife, or shakeoffable devil is an overconfidence in the success of colonial terror. Some people just have so much joy yet to spare. *I'm fucked up, homie, you fucked up / I told the storm to pass.*

"Alright" occurs like a change in air pressure. It augurs a particular weather. Everyone hears ALLS MY LIFE I HAS TO FIGHT and makes preparations to visit the opposite of fight upon one another.

What does a film that smells this lamb's blood in "Alright" hope to say about itself by ending there? Black movie with its Black director in which the federal government as the lone gunmen as the Klan do everything to onscreen Black folks as Black folks offscreen already know the federal government of the lone gunmen of the Klan been doing to Black folks forever, some times for the screen, and all within an hour and a half. A trap-lord hero needs a good Christian woman, but at least Spencer

Williams didn't write Staten Island, and we are thrilled to see ourselves as Black Rambo picking off a small militia after this movie Dylann Roofed a whole congregation—sound effects considered so completely you hear the screaming down an alley the other end of the street—because Y'lan is fine, and don't you want a veiny fist that can throw three fat asses around at once? The resilience with which he steps over every hashtag bleeding out down the halls of the high-rise projects, my god.

One thing about representation is people swear they want to be *shown face,* and what they mean is *hold that pose.* How they do. They can't actually see you, and I don't mean because it's necessarily impossible to see anyone, but because at the risk of truly recognizing how unimpressively sad and ramshackle of spirit it is perfectly possible to be in this world, at this age, they might see how, for all that good, impeccably paratactic shit they talk about overcoming sadness like a brushfire chewing the ass of a hedge maze, it hasn't diminished the solitude of that waterlogged park bench in the center with the sagging slats. To them, if you can cock-strut in front of a ruin, no one gets to call it devastation. Now won't you celebrate with them.

"Alright" at the end credits of *The First Purge* is an apology with Bruh Man's slouch and grin, or my actual brother's usurping anyone's horror with his own humor, like *my bad but that shit was slick,* and he sure thinks so, or *But did you die?*

No. Not every mo(ve)ment in commune is divine, and some of that spirit is parasitic. And you know what? I'm sick of y'all.

Your mentorships and highnesses. Your creepy righteousness after assault, euphorias you extract from draggings. Your but-did-you-dies. Big dawgs, swinging your Black care.

You want everlasting gratitude for keeping the kids sick. You like the sweet, sweet fever on their foreheads, how it steams. You dream like the Department of Education and no one can leave who feels good as hell gettin paid. I get it: *we* eatin, so why the fuck am I trippin? I get to stand next to you in debt to your self-services, but you don't wanna look the part. You want it to be about the art, but no one who stands close to that really gets put through it. Humph. Strungalong and bitched across the good

glistening walls because who's gonna do for us like us? You ugly because I'm ugly. All my life I had to fight my life. But we present one front, one people, one proudly limping panther the camera eye-fucks with its gaping frame, slum we loyally forgive you for loving to see gutted. And no one juking to protest music watches you follow me inside, where you say I make you do this. Follow me inside, I mean.

Every day, Franck drives down to the lake to cruise. He does this with such regularity that, presumably, he only exists at the lake. He previously sold produce, and now he is "thinking of what to do next." Some days he gets lucky and another man jacks him off in the lush brush above the shore. This is Europe and only white men exist at the lake. Some sunbathe in the nude on the beige pebble beach. Some watch Franck fuck. Some, like Michel and Ramière, may have whatever is meant by a "swimmer's build" and swim in the lake; Franck is also one of these, while his new friend Henri is not. Henri is a logger. The tree cutter and the former fruit seller sit together in the sun and mutedly discuss their estrangement from the raw materials of love. As a compulsion, the camera attends to their coming and going: emerging from the water, ascending into the woods, Franck's leaving Henri behind in his doggish eagerness to sniff at the knees of Michel, Henri departing alone across the small rocks, tenderly treading the restless terrain toward his more intellectual depression.

Before they are expelled by the same warm, golden secrecy that binds them like a haze of midges here, the men browse the green brush and regard each other. No other animals roam among them, no wild turkeys with heads twisting on rope-cord necks. They revolve in patient appraisal, quite like satellites, casting their penumbras over this and that prospective encounter, intersecting their fleshed atmospheres in brief studies of texture, vapor, and visual tyranny, hoping always to detect the most cataclysmic magnetism possible in the man, beginning with his pleasing edges. He is otherwise nothing, ideally. In every other ecosystem on earth, he vies for and performs nomination, indeed is empowered by his name and ability to name. But this is hardly a garden. It is merely scenery. Here, nomenclature diminishes his ability to be anyone, his availability to be therefore a serendipity in the randomness of unintelligent design. Less needs to be known about him than about the species of vine beside which he and he will empty his swollen scrotum: that to find in its presence one's life removed from the movement of time will not be regrettable.

Like this, the men could go on forever.

In another country—the wide ocean shrunk to a spitting distance between their respective regions of the imagination—arrives Stéphane Bouquet's *The Next Loves,* translated from the French by Lindsay Turner. "Holy fuck!" Maureen N. McClane blurbs: "Paris, New York, the remembered city of Rimbaud . . . Schuyler . . . O'Hara . . . blowjobs." "O'Hara," "Schuyler," "Creeley," rosters a review by John Steen, who writes too, "What's queer about Bouquet is not just that his desire is for men, but that his poems embrace desire's strangeness, perversity, and multiplicity." *Queer* is a breezy, lazy sundry here—rather than a bewildering malaise—inside the sort of semantic construction that becomes as probable as inevitable when the literature wishes to remain chained to its pillars of singularity and distinction while skimming the hot, bruised skins of a vernacular throng. *What's [gay] about Bouquet is not just that [he's gay], but that his poems embrace [sex].* *The Next Loves* arrives as a tributary to a body of text that keeps milking hookups for inexhaustible tenderness ("indefatigable sweetness," blurbs Garth Greenwell), for the seemingly ironic surprise of loneliness to be found there, for what it *must* say about everyone that among these men's rapacious desire for themselves is the claustrophobia of an endless internet, the apathy of national borders their bodies freely penetrate, and no lasting satisfaction. The text, amalgamating its reviewers and influencers, reserves and replenishes the right to be solipsistically shaken by this, its own existence. Let's apprehend from the text that only gay white men are dying while gay white men are fucking, that the only crises amplifying in stereo sound while they spar with the boredom of empire are the suicides and persecutions of other gay white men—listed by name in Bouquet's often-lauded long poem, "Light of the Fig"—who won't or may not live to duplicate this practice of orgiastic irreverence.[1] Their knotting and breeding boisterously like bushels of octopus eggs is infinitely transgressive, as it is the final and most modern stain of outlaw in their nature. And this stain is desperate to resist immaculation if the text is to continue representing the entire spectrum of experiences lived by

1. Stéphane Bouquet, *The Next Loves,* trans. Lindsay Turner (New York: Nightboat Books, 2019), p. 37–45. This poem otherwise odes on translingual estrangements from/with a Turkish lover between parties and Attic guided tours.

any people who are, well, not heterosexual. "[I]mmortality," Turner translates, "needs a global language."[2]

It is a mistake to grind this axe in the middle of pandemic and rebellion. No writing requires leaking self-consciousness from its seams to be seen as writing done well. With a film script, you can make Octavia Spencer mammy every central character through yet another integration fantasy—in this example, Guillermo del Toro's slop-sweet *Creature from the Black Lagoon* remake—and leave her stranded in the rain with a cat-raising painter who'd rather watch Betty Grable numbers than acknowledge documented acts of state terrorism against Black people.[3] And you can make Octavia call the cops to rescue Sally Hawkins and remain there, unbothered, at the bloody scene of the inexplicable murder of a family man, cat-gay intact as the only other witness while Alexandre Desplat orchestrates solemn resolution out of mud. And you can still get the nomination for Best Screenplay. You can still win Best Picture, Best Director, Best Original Score.[4]

No one *has* to do anything. Not the first openly gay presidential contender, not his cops. They just have to *be*. Harvard Business School's Jacob Meiner, Class of 2020, "want[s] to be the first openly queer US Secretary of Defense,"[5] in the most self-assured illustration of Chandan Reddy's inquiries into US legislative enfolding of gays and lesbians after the 2008 election of Barack Obama.[6] (Specifically, in the chapter "Beyond a Freedom with Violence," Reddy proposes: "Rather let us ask why US law in this historical moment desires gays' and lesbians' desire for recognition. Why does it solicit this desire? What vulnerabilities and instabilities are created when national norms such as the law desire

2. Ibid., p. 38.
3. *The Shape of Water*, directed by Guillermo del Toro (2017; 20th Century Fox).
4. "The Shape of Water - Awards," IMDb.com, Amazon, accessed December 21, 2022, https://www.imdb.com/title/tt5580390/awards?ref_=tt_awd.
5. "Perspectives: Jacob Meiner, MBA 2020," *Harvard Business School*, accessed December 21, 2022, https://www.hbs.edu/mba/student-life/people/Pages/perspectives .aspx?profile=jmeiner.
6. Reddy, *Freedom with Violence* (Durham: Duke University Press, 2011).

GLBTQ desire?")[7] The thirst persists for firsts as ameliorative, sustained endorsements of social abjection. The internet insists young Joe Biden was a babe; Harvard (again) remarks "his formerly chiseled jaw."[8] An image of young, open-shirted Justin Trudeau interjects.[9] Similarly, any of Bouquet's *Loves*, transcending anonymity or not, opens like a tab and exalts a reliable set of qualities:

On Facebook someone posted & thanks
a youthful face reading a poem
[. . .]
I start you over on repeat
bright reader of the poem Adam Fitzgerald as
[. . .]
on Youtube others have shared
their thoughts about you UR A QT says heyyoumillionaires
 which is really
completely true[10]

By page or by poem, Bouquet rotates from "youthful" "bright" "QT" to the next, and this action in itself appears, to those invested in the infinite transgression of gay (white) sex, to be nostalgic of the politically resistant. In this other country—where people like to hope for certain scenarios in liberal absurdity such as poetry's existing, by default, in opposition to the values of oppressive regimes, or like fascist ideology's final days somehow coinciding with the death of a roughly distinguished generation of voters (e.g., "baby boomers")—Bouquet's speakers enter, amid a fanfare of euphony, lucid and drooling:

7. Ibid., p. 193.

8. Caie C. Kelley, "Young Joe Biden Was a Hottie," *Flyby*, October 2, 2014, https://www.thecrimson.com/flyby/article/2014/10/2/young-joe-biden-was-a-hottie/.

9. Eul Basa, "The People Have Spoken: Young Justin Trudeau Is Hotter Than Young Joe Biden," *Narcity*, June 19, 2017, https://www.narcity.com/ca/on/toronto/lifestyle/the-people-have-spoken-young-justin-trudeau-is-hotter-than-young-joe-biden.

10. Bouquet, *The Next Loves*, p. 22–23.

His screen name Blue Adonis
6"1' 21yo top eyes blue cataract of blondness
& in my stupid heart the pure curare of beauty

"Beauty" as a "pure" essence to which the "stupid heart" reacts—a heart, presumably, unassailed by intellectual haranguing 'round the question of beauty as other than essential and naturally conferred. Beauty as providence: Hemsworth, Evans, Pratt, and Pine. His beauty is his structured sheen of chaos immunity. In this country, we've paid for the right to expect that, no matter what state-legislated genocidal act or industry-driven climate catastrophe happens, his face, his jawline, his blood pressure and credit stay steady. Unbothered in his vocation to bother, he is as attractive as expungement, or the distance between an Amazon warehouse and the front door. To gaze on him is not to look away from violence but to bend to violence's incontrovertible convenience.

Nobody has to do nothing. The Discourse is tired and slouching forward into the shore. Like that clueless body of the stoned boyfriend in *Jaws,* it just kinda drops. The rocks wring it out. The spirit of the cruising spot speaks—toothful, dooming—something like, "You don't gotta like [the text] to admit [it] tells [it] like [it] is." A premed college roommate who sketched body organs for fun said shit like that about Trump, and everyone thought he was the sweetest because he played tennis and otherwise kept quiet.

There is horror in indiscretion. If the cops find out what Franck knows about Michel's drowning of Ramière, they shut down the beach and dissolve the one stage where Franck's infatuation is allowed to play tragically out, and he resumes authoring his own bland protagonism with no respite of foray into fable. There is horror in anonymity too. Your towel and sneakers could bake to a crust three days in the sun and no one would say anything or assume the worst. Perhaps they may wonder where your body's gone while lamenting what they would've liked it to do, which is a way of relating to others that you might have wanted shortly before you didn't. Attention used to follow you with its eyes between branches, its shiny tongue pulsing avian against the waxy leaves, and now not at all.

When the camera is no one, it surveys Franck's face as Michel fellates him on the lakeshore: his face in disturbed recognition of this pet-sematary sex, the exhumed blue bride of it: that what he's wanted with so much heat has arrived not exactly as he dreamed it. His face, at the usual threshold at which he could resist Death's solicitous narcissus . . . it's hopeless. Death's entire countenance is Desire. It has a scandalous stache. It eats good ass. Franck's face, in the seconds the condensation between Michel's cheeks becomes audible, now in acquiescence: Franck will absolutely make love to this murderer. It's clear from the breeze in the treetops and the bands of black waves on the lake that there is no reining this in. He will deceive and abandon not just himself to make this love forever.

Night rises through the ripples with straps and sweat. Submit to it. Only in the beginning is the water cold. Some pilot light of heaven blossoms indigo in the inner thigh. You are as easy there as the muscle of a pear. (Get into it.) Everyone will meet disaster somehow. (I'm into it.) All will be destroyed. *We can't stop living,* Franck tells the detective. If you want the end of the world to at least feel good, what if it could always be ending? What if, in order that you should easily become the queen of hell, it has always been ending somewhere, for someone else? In a way, what Franck does to himself isn't abandonment at all. Not even close.

MOVIE PITCH

Crop Tops: a gay slasher in which, obviously, somebody is stalking & stabbing up tops & that explains why there are never any tops in the city.

the plot follows a protag who gets anxious about the grisly killings of local tops & considers bottoming in self-preservation only to discover more frustrated bottoms everywhere. friends of the protag spearhead a ragtag lynch mob to hunt down the killer, but now that they aren't all competing for the attention of tops the bottom mob incidentally find themselves communicating openly with each other about the thankless horror & humiliating labors of bottoming. they do eventually find the killer in the toy-filled sex dungeon of a video store, but by this point they're basically communists & are teetering on the brink of a social revolution based on mutual care & non-exploitation, envisioning a society where tops are outlawed by penalty of death.

key kill scene:

we see a faucet dripping into a bathroom sink full of hot water & pan over to the small bedroom where a bottom, nude on knees & elbows over a douche nozzle & an iphone, is mid-chat on Grindr & has just sent the address. cut to a well-furnished living room: the top, supine on a sofa & lounging in expensive activewear, ignores the Grindr messages coming in between bong rips. cut: the bottom flushes a toilet. cut: the top plays *Call of Duty: Modern Warfare*. cut: the bottom refills the douche. cut: the top microwaves mozzarella sticks, flops back onto the sofa & starts browsing newly received ass pics from three other users. d-a-m-n, he replies to one. a closet door quietly cracks open in the hallway behind him. cut: the bottom dries off from a shower & places poppers & lube on an end table & checks the phone again & types out e-t-a-? cut: the top hey-Googles directions to one address less than fives miles away & then another less than two & then belches "fuuuuck" & types out a time that is one whole hour later & then slouches back into the cushions. the hallway closet door is

now wide open. cut: the bottom selects a sexy playlist & anxiously toggles the shuffle on & off while screencasting a web browser to the TV with tabs open to three porn sites. cut: the top puts on a headset & resumes playing COD loudly while the phone in his lap is open to a sent message displaying his dick pic. the hallway closet door is closed again. cut: the bottom, having settled on a music choice, reads the top's ETA response, exasperatedly drops the phone onto a tightly made bed, inserts a butt plug with a long exhale & commences cleaning random corners of the apartment while wearing a black jock strap. the music gradually grows more present. cut: the top unblinkingly fixates on the TV, its blue flickering across his face while he chews cheese sticks, the automatic gunshots synchronizing with the beat of the bottom's sexy music, which we still hear. an indiscernible shadow passes behind him. zooming in toward his eyes. gunshots. fuck beats. big eyes. chewing. gunshots. fuck beats. big eyes. bombs. fuck beats crescendo. the biggest eyes. chewing stops. gunshots taper off. the top's eyes look down to see the hook of a steel coat hanger shoved in the side of his neck. fuck beats continue. the eyes try to follow the hook as a hand slowly drags it across his throat. chewed cheese stick dribbles from his open mouth as he gurgles & rattles. the eyes roll back. offscreen his COD player gets blown up. blood drops onto the phone screen, where blue message bubbles pop up reading "you there?" "hey" & "umm wtf" consecutively. drip drip drip. cut: those same messages, in yellow chat bubbles, blackout as the phone drops onto a tightly made bed. we follow the plugged butt of a bottom in a purple jock strap into another bathroom. the bottom firmly shuts off the dripping faucet.

INADEQUATE VESSELS; *OR* SIMONE WHITE SAYS, "A POEM THAT DOESN'T HAVE ITS OWN MIND FRIGHTENS ME."

> *On February 27, 2020, writers/artists Tongo Eisen-Martin, jaamil*
> *olawale kosoko, and Simone White, as commissioned by Dawn*
> *Lundy Martin, presented responses to my second collection of poems*
> *as part of an event for the Center for African American Poetry and*
> *Poetics at the University of Pittsburgh. At the event, titled "Reading*
> *Justin Phillip Reed," I presented this response (in its original form)*
> *to the prospect of their responding. A video record of the event lives*
> *online. The quotes from Simone White were since added, along with*
> *some edits and, in particular, an expansion triggered by White's*
> *reading.*

Suddenly I feel compelled to consider the textures of virulence and possession. It's winter and a novel cohort of upper-respiratory illnesses assails me from outside, but I swear there's something pernicious living within my digestive tract. It stays with me no matter what I eat or don't, what rail I half-grasp on the bus or what vapors I inhale in the university elevator. At night, my intestines twist and bloom as though in compact imitation of that one scene from *Annihilation,* and I am both accompanied and abandoned in the bedroom.[1] If I whine like a dog kicked in the ribs, I let the pillow muffle it. I struggle to describe to others what I suspect is the same strain of pain that plagued Dan O'Bannon to conceive of xenomorph impregnation; his Crohn's disease killed him. The doctors remain mystified. They prescribe me immune suppressants in flu season. They busy me with lab tests. The way my body appears filters "pain" before it hits their ears; that is, they hear "discomfort."

1. In "that one scene from *Annihilation,*" the expedition led by protagonist Lena (Natalie Portman) discovers video footage in which her husband Kane (Oscar Isaac) carves open a fellow *living* soldier's abdomen to reveal mutated, serpentine, moving innards. Kane puts his hand in the cavity; the tentacular intestine slides across his palm. He is amazed. The opened soldier shudders, panting while he's pinned to the wall of the pool. Another man places a kiss on his forehead. *Annihilation,* directed by Alex Garland (2018; Paramount Pictures).

I play host to this mysterious science fiction while three differently ill artists enter my book before it can run and set about transforming it. The book will, from this moment, never again be quite what it has been. There will be a weird little wriggle in that glisten of its cornea that wasn't there before. Wasn't? Was it? Wasn't I too enamored to notice? I wrote the book I wanted while living in a city that I loved, in which, on most days, I knew gladness. We have left that place. Maybe my beloved always stayed awake all night, siphoning confidences from my lungs with fishing line and watching me spring my nosebleeds. It's better to know the book was never mine—or ours, my friends—but is its own chaos of transmission, like a skin. I came this evening prepared to receive its raw hell face, its basic brain, its vulnerability to light, and its saddest humanity.

How is infection like reading? It all happens so quickly. One day you wake up in the sunken place of a sickly creature, and your body despises your life. Yesterday, I believe, I began to hate the book.

"I hate this part," says Jillian Armacost to her husband Spencer. "You're still here but I know you're going, and I hate that." It's the eve of Spencer's mission. It's the opening scene of the 1999 film *The Astronaut's Wife*, starring Charlize Theron as the wife Jillian, Johnny Depp as the astronaut Spencer, and Joe Morton as the disgraced NASA rep and sacrificial negro Sherman Reese.

As happens to Charlize in *The Devil's Advocate*, another husband with a random and overexerted Southern accent uproots her into apocalyptic preparations. Except that now she has Rosemary Woodhouse's haircut, and perhaps the film is desperately devoted to *Rosemary's Baby*: there's the latter's witch surname "Marcato" hidden inside "Armacost," and there's John Cassavetes's son as Alex Streck, the astronaut whose body couldn't hack extraterrestrial possession. As Alex and Spencer attempt to repair a satellite, there's an explosion. NASA loses contact with them for two minutes. Something else comes back to Earth's surface dressed as Alex and Spencer. (Simone White says, "This was the conceit of *Scooby-Doo*.") Alex dies of a massive stroke. "He's hiding inside me," Alex's wife Natalie says to Jillian at the wake. Natalie takes a bath with a radio between her legs. Spencer relocates Jillian to New York City, where he becomes a corporate

exec occupied with designing a war plane that will deploy radio waves like an EMP bomb.

Jillian's drunk. She wants to know what happened to her husband for those two minutes he was both accompanied and abandoned in orbit. For pressing the subject, Spencer punishes her with rape and pregnancy, though the film stylizes his coercion to sound like seduction—the score deepens, her pulse grows audible, he speaks in husk—while the camera pans in curves. What invaded, violated, and occupied Spencer merely spiritually now conducts Spencer's body to commit the act against Jillian in ways that mark the thresholds at which motherhood, distrust, social isolation, and physical abuse all enter. "Dark," he says about the moment that changed everything:

Black.

No light.

No light.

It was black.

Silent.

No sound, but

but loud, something loud . . .

It was death.

This black death's loud silence is something of the blood-taint anxiety riding these all-American couples to their ruin. It exploits their aspirations to empire. It replaces them in hegemony. It weaponizes their environments to disregard their suffering. It forces any fantasy of benevolence in their propagation to dissipate, clarifying their children's membership in a globally destructive ascendancy. And it moves at first in an esoteric code that only Sherman Reese is able to translate. It's not just that Reese spends half the film behind the scenes, losing his job, his mind, and then his Blackass life in order to supply Jillian with a whole storage room of foundational evidence that Spencer is dead and she's carrying the twin offspring of his killer. It's also that, in the end, it doesn't matter. Dude gives himself up to ash, knots, and jaundice just so Jillian can pivot and keep the kids and absorb the father. How much commendable, lamentable sweat, stress, and text erased for the sake of rabid replication, relieved from the omnipotence of nuance, overwritten by ravenous vacuity, complete absence of conscience.

That shit is disrespectful and I want it, some times, want the levity of its immaturity. So, I wrote poems from the vantage of monsters who won't be reasoned with, and who stampede into the oblivion of consequence. Until then . . .

"What's happening?" is frequently all that Jillian can say about her life. Along with the growth of the unknown within her, the unknowable city glowing chrome and gray outside her resurrects her mental illness. It is the specifically not-Black illness of visualizing herself and the people she knows dying violently; in her world, this is irregular and previously found her hospitalized. Meanwhile, her husband and only friend is corrupted by a being and a language that utterly elude her. At dinner, the men make their mouths assemble phrases like "twenty-five thousand pounds of thrust," "wingspan fully extended," "a ceiling of fifty-five thousand feet," "planes and tanks and computers and missiles all humming away," "an electrical blizzard"—the hostile environment that their little fighter flies into. (Simone White says, "I'm currently enraged, in a way, by certain kinds of speech.") The text of this, the plosive enunciations, accumulate a surface of force and cold calculation around Spencer.

How will Jillian survive this place. How to introduce any creation into it. How to expect what once brought her support, pleasure, and adventure to ever again provide anything other than destruction, confinement, and fear. I mean to write something here about what is called a writing career, but who, at this moment, the fuck wants to hear it? Jillian's thwarted abortion is not even loosely analogous to the writer's reluctance to be personified by the well-received book. (Simone White says, "I'm thinking about why metaphor, which is common as dirt, makes me so mad.") Whatever annoyance flanks the projection of lustrous production, however the honest-to-goodness interior flares its one-eighth-second *Exorcist*ic demon's visage, no matter how determined the cult of killing darlings, the violence does not cross the limen intact.

•

What is a poem's own mind? The question fevers me, as it's posed to do. Sherman Reese only appeared to be out of his mind to anyone unused to

seeing. Jillian tried to distinguish the apparitions of her wrong mind from a wrong reality in which Spencer was not in his own mind at all. Simone White says something about Emerson but, maybe because my nerves are bad, I hear "Auden." Not in the way someone is always hearing Auden if recently reading Auden, but still. Auden, who famously declared, "In so far as poetry, or any other of the arts, can be said to have an ulterior purpose, it is, by telling the truth, to disenchant and disintoxicate." "Auden, however," Seamus Heaney offers, "practiced more enchantment than this would suggest"—Simone White says, "You could call it 'bewitching.'"— "so it is no wonder," Heaney continues, "that [Auden] was impelled to keep the critical heckler alive in himself."[2] I'd like my inner critic to heckle as Jada Pinkett as Maureen, watching the film *Stab* inside the film *Scream 2*, saying, "If that was me, I would be outta there," unaware that it's too late for her to escape the theater / the film / the correlative kill scene. That metanarrative flourish, which I find the most satisfying in the *Scream* franchise, foregrounds perpendicular consciousnesses. Maureen's: fallible, soon to conclude, facing out of the film. The film's: supreme and taking off, facing inward. Now, I want a formula for such a coordinate in order to, on some Turing shit, locate the moment at which the sovereignty of the text's intelligence (let's say it exists) attains animation. Perhaps it'd coincide with the regular thanatoptic-erotic pangs legible in Simone White's writing "what I meant when I referred to his prose exertions at the very start of this *(long)* essay,"[3] or "I was trying to get *off* this page."[4] Perhaps not.

As for "any other of the arts": if a thumb-through glam thriller motion picture like *The Astronaut's Wife* can at least withstand interrogation as art—and in the film's defense, it treats form as necessary illusion; its content is actively concerned with bewitchery; its dénouement is dependent on disenchantment; and therein it manages to tell truths (if we agree that *capitalist aspiration can obliterate people from the insides out* is a truth)— then I'm prepared to deal with what I read in this artwork, based on its

2. Heaney, "Sounding Auden," *London Review of Books*, Vol 9, No. 11, June 4, 1987, https://www.lrb.co.uk/the-paper/v09/n11/seamus-heaney/sounding-auden.

3. White, *Dear Angel of Death* (Brooklyn: Ugly Duckling, 2019), p. 133. Italics mine.

4. Ibid., p. 89.

overstated awareness of influence or shameless commitment to homage, as the rejection of its own (textual) mind.

I'm thinking that this rejection could be central to ~~the film's rai-son d'être~~ *why the film is,* in that its reiteration of a received narrative enacts simultaneous coverage of the problems of infection, influence, and transmission that preoccupy it in content *and* in the air around the container itself. This isn't the awareness with which the hallmark of American sexual repression makes resurrecting Jason Voorhees always profitable, or even the postmeteoric, sophomoric depression in which *Exorcist* sequels were a motion that had to be gone through. Consider, rather, *The Astronaut's Wife* as an exercise in patriarchal fatalism and, therefore, profuse capitulation to the anxiety that Pier Paolo Pasolini's suggestion in the sixties—"that, far from changing society, writers and filmmakers can do little more . . . than offer passive resistance to the irresistible tide of technological neocapitalism"—would be no less potent in the arriving millennium.[5] This futility is more damning because Jillian is a schoolteacher. She marries another pilot. She sends her alien twins to school. She speaks in a voice that is ab-/new-normal: lower, certain, sexier in that way movies imagine possessed people sexy (read: dominant). She "achieves" individual purpose and familial companionship by falling victim to a diabolical inevitability. And developing minds are at her mercy.

On my way to the poem's own mind, through the woods of the horror film imagery that influences my poetry, I meet a few granted presumptions I need to look in the eyes and name before passing on.

First, that *the film is analogous to the poem.* Creators of adaptations of poems think so, certainly, in ways that better serve adaptations. But, to my mind, there are vectors, specifically illuminated by the horror genre, to be traced from myth through fairy tale through film script, or from myth through ritual through theatre through film, all of which are conveyed by language that is invested in the reorganization of conventional signifying—which tends to be ascribed to poetry. Carl Phillips

5. Naomi Greene, "Theory: Toward a Poetics of Cinema," in *Pier Paolo Pasolini: Cinema as Heresy* (Princeton: Princeton University Press, 1990), p. 93.

has already related camera direction to more or less classical poetic structures.[6] Pasolini, in *Al lettore nuovo,* asserted to his "new reader" that "*a certain way of feeling something* was identical" when comparing his film direction to his poems.[7]

The second presumption is that *any artwork has its own mind at all.* That it either (1) possesses some primordial or pure (as *if* alchemically precipitated) intelligence that is not merely emissary of the author's own; or (2) computes, signals, or even dreams in the wake of stimuli received from other intelligences, and then, by summary of how we perceive its resultant performance, sufficiently represents to the skeptic an original thinking. (Simone White says, "I'm fuckin with you a little bit by performing a literary-critical explanation . . .") Does an artwork appear to have its own mind simply when the audience cannot trace its hermeneutic nexus? Or when that trace cannot account for the artwork as received? In the first case, there's a way Ari Aster's *Hereditary* appears to have its own mind to people who don't consider horror films in discourse with each other. And in the second case, arguably, there is Bill Gunn's *Ganja & Hess.*

Art that doesn't stop at abiding by its own natural laws, but that has no natural laws or has natural laws it doesn't respect—the latter being, I suspect, the fullest exercise of compounding the *intuitive logic* and *normalized magic* that Kate Bernheimer traces as elemental components of fairy tales—I experience this sort of art in/as peril.[8] I've found Disney's *Alice in Wonderland* more deeply unsettling than most films classified *horror.* I sat agape and in sustained anxiety as exponential masses of self-involved strangers relentlessly invaded the protagonist's home in Darren Aronofsky's *Mother!,* but that's because I have this problem called "home training" and don't like people making messes in my space and not cleaning up (a problem that I worry inhibits me from inhabiting true lawlessness). But the prospect of the film or the poem effecting in me, the

6. Phillips, "Little Gods of Making," in *The Art of Daring* (Minneapolis: Graywolf, 2014), p. 8.

7. Cited by Greene, "Under the Sign of Rimbaud," p. 18.

8. Bernheimer, "Fairy Tale Is Form, Form Is Fairy Tale," The Writer's Notebook: Craft Essays from Tin House (New York: Tin House, 2009), 61–73. http://www .katebernheimer.com/images/Fairy%20Tale%20is%20Form.pdf

host, a disorganization more enduring than that in the artwork itself: this is what *I* find frightening, and attractive. I do not know how to teach poetry. I don't know how poetry happens. I don't know what possessed Gwendolyn Brooks to write "And I was hurt by cider in the air." We never hear in *Mother!* the poet's poem—which must be a poem to end all poems to elicit the response it does—because the film would have to define, by creating it, the (impossible) ur-poem, and would therefore succumb to incredibility and contrivance, totally and immediately.

Façade falls. Fourth wall with holes in it: a mounted portrait with roving eyes. I'm not sure I'm sorry my poems can't be trusted. Not everything with its own mind is guilty of original thinking, or even interested. A person, for instance. Something must hide inside and bewilder. The grandmother suit bursting at the seams, the wolf gets away from itself in salivation, horniness: the scene is captivating. Perhaps the practice of the rejection of preciousness, which often eludes my good home training, allows Simone White, who is brilliant and does not fuck with my book, to infect and permanently fuck with how I experience that book and its poems that mean to participate, ambitiously, in the simultaneous reproach and rejection of canon, and especially the canonicity of good Blackness. And what about such a book is too sacred to succumb to total and immediate revision?

I haven't read as many books as Simone White, that's obvious. I do try to be attentive to the intelligences of horror culture iconography that folks otherwise tend to deploy for cuteness or dismiss as cheap tricks. And I have watched a fuck-load of *Scooby-Doo, Where Are You!*, the conceit of which doesn't end in the mask-off refrain, doesn't cease in the revelation that the monster is always a person. *Scooby-Doo* villains are people who hide inside the inexplicable as straw men for underhanded exploits, cheating people who get inheritances out of their inheritances or thwarting the operations of wealth-hoarding institutions. The Mystery Machine team always cooperates with cops. Shaggy and Scooby always eat somebody's groceries on the low. And, on their way to help send another masked man to prison, they break a lot of shit, slapstick. Mess for the hell of it really aggravates me.

BLACULA STILL A COP FILM (AND SO IS WE)

for francine & Charleen
presented at the Watering Hole virtual retreat, December 2020

"People fuck up when they send a representative out."
 —Tongo Eisen-Martin

"A stance like mine, of *devotion* [to an idea], gets instantly more
problematic in a fascist-tending time."
 —Wayne Koestenbaum

•

I want to set out here with a sovereign intent to mind my own business.
As an objective, it ought to focus my inquiries within the endlessly fear-
some and necessary practice of self-awareness, and foreclose from me any
regrettable, amateur criticisms I might otherwise make of my contempo-
raries and not, more appropriately, of myself. I mean to describe what's
happening in my mind without resting on—as though in some apology
for navel-gazing—the institutions of literary aesthetics that tend to police
Black expression, however opportune they might be in consideration of
Black work that itself polices Black expression.

Regardless, I have talked so much shit in such a short time that I may
never catch up to the truth of myself without having first been a liar.
And how can I be accountable to and adequately collaborate with lan-
guage, and how hold myself to a standard for this, if I'm always sitting up
in other people's business, in the feeds, being totally permeable to input
(text, DMs, WhatsApp, email), only reproducing the language I receive?
And yet this is how folks expect to show and be shown care. I'm afraid of
how young and impulsive I can be, how loose of tongue, how distracted,
inattentive, reckless. Have even said "police," aligning matters of opinion
with homicidal bloodlust and incarceration. Yet people keep asking me
to speak to, and for, and at.

Individualism is a trap. The US proves that. So too, perhaps, is compulsory community or collection that disregards the asynchronous relations of autonomous individuals.

Though I might aspire toward an active use of what Dionne Brand phrases as "an *I* that exceeds the individual *I* and makes expansion present,"[1] and though the superimposition of Black synecdoche is some hard shit to want to shake,[2] I admit I demur now to write—as I live—in it / behind it. Pondering (as I do lately when left to general devices) the conditions of horror protagonism, particularly the dual vicarity of assailant and assailed, and referring to that self-consciousness that draws my projection of myself parallel to my anticipation of other people's projection onto me—as in two contrapuntal frames in which, simultaneously, the world opens and the world shutters—I texted a friend: *Blk ppl live in split screen.*[3] Risking their affirming, triple-exclamatory reaction, I should have more accurately proposed: *I have this experience of living, and I suspect you do too.*

My sudden, nervous will to back off of the first person plural—after having subjected, with elation, so many poems in my second collection to its speakers—isn't limited to degrees of innocence and ignorance that I sensed burning away from me in hearing Saidiya Hartman say, "I'm

1. Quoted from "These Tyrannical Times: Poetry as Liberatory, Poetry as Undoing," a conversation with Harryette Mullen, moderated by Emily Greenwood, presented by the Center for African American Poetry and Poetics, September 28, 2020.
2. Thanks to Douglas Kearney for bringing this to mind during the Q&A for his lecture "I Killed, I Died: Banter, Self-Destruction, and the Poetry Reading," presented by Cave Canem, September 25, 2020. "But my body being present up there as a kind of vessel is complicated . . . For [my voice] to be a synecdoche, you have to acknowledge there's something else there."
3. And here, I'm thinking alongside the opening Toni Morrison ascertains—i.e., of imaginative possibility—when a Black writer removes "the gaze of the white male" from consideration, though my aversion is to any limiting, presumptive external gaze, even one cast in compassionate intention or, yes, love. Quoted by Ariel Leve, "Toni Morrison on Love, Loss, and Modernity," *The Telegraph*, July 17, 2012, https://www.telegraph.co.uk/culture/books/authorinterviews/9395051/Toni-Morrison-on-love-loss-and-modernity.html.

always trying not to position the dead in service to our romances."[4] Not that I had been any more obscenely romantic in my textual enlistment of (a decidedly uncomplicated vision of) a wronged, worrisome, and ultimately vengeful body of the dead than other writers had been about the living, their vernaculars, and what poetry they deserve . . . but within the jurisdiction of my own business, I ought to only pronounce *my* bads. And I *had* attempted lyrical necromancy, taking for granted the simple fact that not all us—dead, undead, or alive—desire identically. Furthermore, I hadn't done enough of the terrible work of knowing me to write me without incorporating *we* into *my* crusades, inviting all manner of contradiction that I did not have the proverbial juice to poetically perceive, much less to conciliate.

I'm saying, forgive me: I don't tribe well, and often don't vibe with *we,* which I'd assume is news to few who know me to any remarkable degree. Why, then, have I made my art accessory to a misrepresentation I claim to want out of?

I imagine the answer is ado with fashion, a matter of flavor and gratification. This isn't about how I don't smoke enough to love Frank Ocean and that I feel blasé about Solange—and have frankly survived too much strife and social torture to pretend otherwise—but almost. Rather, there's a need working in me to contend with literary poetic text as a market-destined and, therefore, market-*influenced* production, and to contend with the risk that my literary "communities" are similarly produced.

Ahead of this retreat, the Watering Hole asks: *What was the best advice you received as a young poet?* I consider myself a "young poet" yet, which I take to mean someone whose poetry hasn't accepted a steadiness of habits that are, together, given the elusive term of *voice;* whose poems individually

4. Quoted from "Looking for Language in the Ruins," a conversation with Erica Hunt and JJJJJerome Ellis, presented by the Center for African American Poetry and Poetics, September 29, 2020.

continue to resist a certain frequency of recognition, even to themself, as issuing from the same author; or whose poetic practice, regarding external influence, retains a characteristically youthful urgency *and* attention deficit. I've written things in the last five years that I no longer believe. As a young poet so defined, I'm coming to problematize advice, which—as long as *poet* remains a category of employment or professional vocation—is career advice. As a young poet, I suspect that Black poetry in the realm of professional writing is having what I'm only comfortable calling an "experience" among late-capitalist fashions of the prerevolutionary debacle that is the United States of America—an experience so novel and so publicly underscrutinized (at least, directly) that *advice* is more likely to be dart-throwing motivated by the egotism of institutional ambassadors such as myself, rather than to be practical, careful work of the specific, personal mentorship or counsel with which it is dreamily associated. "Do anything for clout" is, to me, both catchy and a method of getting my art caught up in a system of estranging practices that maintain an irreducibly abusive relationship with Black people. With this (bad) attitude, and with this anxiety of influence, I think it inappropriate of me to forward advice that has yet to show itself foundational or even reliable—advice that applies to conditions that are impermanent (e.g., arts capitalism) and in flux (e.g., young poetry of the imperial US).

If anything, I cling to these lines from Bill Gunn's 1973 film *Ganja & Hess.*

> The result of individual thought is applicable only to itself.
> There is a dreadful need in Man to teach.
> It destroys the pure instinct to learn.
> The navigator learns from the stars.
> The stars teach nothing.

I read this—and, indeed, (the character) George Meda's entire poem-cum-suicide note prefaced only "to the Black male children"—as a meta-commentary on the formally aware experiment of the film text, a creation itself made possible by the bourgeois venture of Blaxploitation while in

rebellion against it. This contradiction recalls to my mind filmmaker Pier Paolo Pasolini's pained dilemma, as quoted by Naomi Greene: "While I live the struggle against the bourgeoisie (against myself), at the same time I am consumed by the bourgeoisie, and it is the bourgeoisie that offers me the modes and means of production."[5] Having witnessed the formulation and repetition that consolidated that profit machine sometimes proposed as a genre in its own right, might Gunn—like Pasolini, a metaphrast of cinematic convention—have written this text as a gesture against forcing his subversive, antigeneric artwork into the position of a didactic prose? *The stars teach nothing,* as if to say: "This exists. It *is.* It does not advise. Don't follow me up." Perhaps to punctuate this sentiment, Meda/Gunn crumples and discards the typewritten poem. But the poem, offered in the key of advice "to the Black male children," having been vocalized, exists in the film. And the film, though previously mutilated and hawked, was restored in 35mm print by the Museum of Modern Art, and is mass distributed on home video by Kino Lorber.

Is there any way out of being a Black example? I don't want to talk about the Spike Lee remake.

I titled this lecture "*Blacula* still a cop film (and so is we)" as a way to loose the following considerations to hound my sometimes vain tendency to digress.

1. Ostensibly the first Blaxploitation horror film, and therefore both prototypically a derivative *and* representative, William Crain's *Blacula*—to which *Ganja & Hess* partially responds—synthesizes readings of Black coherence (where such a thing is sold) and its coercive pitfalls. In short, reactions to authoritarian oppression be look-

5. This is Greene, citing *Con Pier Paolo Pasolini*, ed. Enrico Magrelli (Rome: Bulzoni, 1977), p. 91, amid her discussion of Pasolini's "existential tension" as a motivation behind his mythic depictions of the bourgeoisie with a "cold and savage irony." *Pier Paolo Pasolini: Cinema as Heresy* (Princeton: Princeton University Press, 1990), p. 131.

ing like dioramas of authoritarian oppression. Spoiler: the villain is still king-making.

2. I've previously written at some length about "we" as a capacious way of accommodating a Black sense of selfhood that is at once a pluribus in unum as well as—more so—various, contradictory, split into incoherence. (Capitalist language responds to the conundrum of the person by providing only categories of utility by which to identify myself—e.g., "young," "Black," "writer," etc. That these categories are often at odds works out in favor of capitalists: they have the means to determine and insist from many directions what I will be called, such that my protests and ruptures of diction look like maladjustment to reality rather than reality's struggle to emerge. I'm not sure this note goes here.) Here, now, I'm concerned with the ease with which I capitulate to the first-person plural as a way of coddling myself with answers to furious questions I haven't the audacity to ask the other people I insinuate in "we"—namely, *Who are you? What do you want?*

3. If it is, as Brand says, "poetry's major proposition . . . that it will turn language over,"[6] how do I charge myself to not contribute to the hypertextual noise of my literary present a "placatory and palliative" poetry, as Seamus Heaney calls it, that won't instead upend and disillusion the language I take for granted?[7] What, for example, do I mean by "my people?" Who belongs to anyone, and what are the terms of belonging? Why should I speak for them? How am I accomplice to the plots that keep them from speaking themselves? Do I have a practice of calling out my inclination to co-opt the language of "my people" for public effect, knowing that it is en (market) vogue? Does that look like alienation from production? I don't even speak to my brother.

6. Brand, "These Tyrannical Times."
7. Heaney: "Most often, [the poem's relation to our historical moment] is placatory and palliative, and the poem massages rather than ruffles our sense of what it is to be alive in experience." From "Sounding Auden," *London Review of Books*, Vol. 9, No. 11, June 4, 1987, https://www.lrb.co.uk/the-paper/v09/n11/seamus-heaney/sounding-auden.

·

I like a suave mf. Don't you? A big dawg, a heavy cat. A daddy. As a kink, I dig his easy dominance. My back to the wall in shadow play of an inevitable possession is how we do mythology. This is a game, a script, a scenario, a pillow discourse in which we theorize rationales for our reactions to the world. His charisma exists and is effective here because we agree to the conditions of the form, and the form exists as an intentional space in which we satirize arrangements of power. We explore extents of consent. We practice ecstasy here.

But there is a shelf life on being out of lane like this. The form has limits. Beyond those limits, his charm is largely incommensurate. Seated in the social vehicles of their bodies, subject to this planet's gravity and this empire's nonconsensual, molecular interjections squatting in their viscera, people find themselves dragging. His fuckless lightness makes no sense under the external conditions, and so people perceive it as actual divinity. This perception endangers all parties, I think, because people have been told to be desperate for God for as long as their rulers have been drugging, disappearing, and killing their poets and their parents alike. The people have so much literature about the feats of charming individual men and their time on mountains that they don't even need to read it; and so little about communal struggle that doesn't end in cancer, massacre, or fire. They agree on his magnetism. They unanimously yield to him all their own specificities, and then wonder how he came to be. (It's me. I'm people.)

Such is the bulk of *Bacchae*, the two-and-a-half-millennia-old Greek tragedy by Euripides in which power changes hands between men both mortal and immortal, while mothers, daughters, and all the women of Thebes are coerced into murder and left lucid enough to grieve. "What is wisdom?" the chorus asks at the peripeteia, the downturn in the protagonist's fortune, as a disguised Dionysus gases Pentheus into thinking he

can run up on Dionysus in the forests. The chorus repeats, "What god-given right is finer in men's eyes / Than to hold the hand of power over an enemy's head?"[8] Soon after, Pentheus's mother Agave descends into the city, still under Dionysus's spell, holding the head that she herself tore bare-handed from the body of her son. Sparagmos (being torn limb from limb) is Pentheus's punishment for pursuing an ecstasy not divinely provident—egotism, that is—beyond the formal limits of the private.[9] Agave's punishment is living to learn from this.

Two things.

One: the chorus of the Dionysian cult orates in the first-person singular. "I," it enters, singing, "rush on in my joyful labors." There is not individual identity in its midst; it is an indivisible, collective action. Bacchus (Dionysus) uses the mass singularity of drunken, orgiastic Bacchae to attract attention and praise. Typical of a god, he wants to be reminded of his godhood. In this way, the people are the messengers, the pronouncers of divinity; through them, the ignored or otherwise unexceptional achieves apotheosis. (The hyping that happens in chat windows of Zoom readings makes me more uncomfortable than our crowded-room *ooms* because the virtual platform requires overcompensating expression, and exploits my personal yearning to participate in public performances of joy, however superficial. Celebrity solidifies isolation, and soliloquy breeds narcissism, and this is why I cannot bring myself to let the artist fuck. I'm afraid to get it on me.)

Two, speaking of apotheosis: I keep thinking about Korn's "Freak on a Leash," arguably the band's most popular song and the first of singer

8. Euripides, *Bacchae*, trans. David Franklin (Cambridge: Cambridge University Press, 2000), p. 55.
9. "The theme of rejecting a god appears repeatedly in Greek myths. Inevitably such blasphemous arrogance, *hubris*, leads to *nemesis*—destruction." Ibid, p. 2.

Jonathan Davis's many explicit lyrical rages against the music industry's vampiric supplanting of the artist's personhood.[10]

> Life's gotta always be messing with me. (*You wanna see the light.*)
> Can't it chill and let me be free? (*So do I.*)
> [. . .]
> Sometimes I cannot take this place.
> Sometimes it's my life I can't taste.
> Sometimes I cannot feel my face.
> You'll never see me fall from grace.
>
> Something takes a part of me.
> You and I were meant to be
> A cheap fuck for me to lay.
> Something takes a part of me.[11]

Left margin, top: Is this a tactile place? Or is it a Further, a distance that has to be gone toward the comforts of success promises? Charleen says the root of ecstasy is to be out of one's right place.

Left margin, bottom: Something & something dismember the speaker, in a dispensation incongruent w/ their intended low-stakes transaction w/ the addressee. Capitalists exact pounds of flesh. "Hubris leads to nemesis."

Right annotation 1: The speaker & addressee share an aspiration. This is asserted in subtext of a desire for chill & whatever is meant by freedom, which is an allowance here.

Right annotation 2: Before Max Weber, *charisma* was a theological term referring to supernatural or miraculous endowment, from the Greek *kharis* for "favor" or "grace."

Right annotation 3: Grace is to be gripped tightly. The ecstasy after apotheosis could be a kind of addiction. *I mean,* Jericho Brown writes in the poem "Ganymede," *don't you want God / To want you?*

I give a shit about the song's popularity *because* of how the dissonance and disillusionment described by Davis's discrete *I* attain their anthemic position in the genre, despite lamenting an elapsed affair (the long, wrong lane) with this alienating representation. Money being his enemy,[12] his losing autonomy via transformation into a product for someone else's profit rends him (or he is "consumed by the bourgeoisie"), and his singing the agony of being rent distills a mass set of sentiments—that expansive *I*. Mass appeal (what the bourgeoisie offers) further propels him to standard-bearer, icon, lucky star. The stars teach nothing.

10. In a 2018 interview with *The Fader*, Davis is quoted: "[I wrote "Freak on a Leash" about] the music industry, entertainment in general—how the machine worked. The label, management, publishers, everything that it involved. . . . They were taking the fun [out] of making music and making it a business." See NM Mashurov, "The Definitive Oral History of Korn's 'Freak on a Leash,'" *The Fader*, August 14, 2018, https://www.thefader.com/2018/08/14/korn-freak-leash-oral-history.

11. 0:37–1:37 of the track. Korn, "Freak on a Leash," *Follow the Leader*, Epic Records, 1998.

12. See Taylor Johnson's poem "Menace to," in the Academy of American Poets's Poem-a-Day, August 18, 2020, https://poets.org/poem/menace.

A note about craft for the occasion. Given how little I'd know about its triggering subject if not for information Davis delivers in interviews, I wonder if the lack of lyrical specificity in "Freak on a Leash" perhaps contributes as much to its exploitability as to its popularity. "Something takes a part of me" says almost nothing about its speaker's circumstance except that it leaves less of the person. What thing? What part? "You and I were meant to be / a cheap fuck for me to lay" could call to mind any codependency. This is perfect for a metal chorus with a chunky detuned guitar riff and a percussive bass line to make seismic the sentiment's gravity, perfect for a rising arena band performing for churning seas of people at sold-out festivals nonstop;[13] it's inhabitable, nondenominational, uttered as if in vacuo, and vapid of potentially obstructive details. Like a warehouse party or bonfire. It does not do work that folks in the orbit of this lecture ask poems to do—that is, to actively intervene in and show mutable the material of language as it fabricates reality in motion.

The sad irony of "Freak on a Leash" nods to the ways different arms of white wealthy hegemony concede, absorb, and reward the language of dissent. The "resistance" vote. University-wide "antiracism" initiatives. I've completed two creative writing programs in which poems and essays were met with suggestions of inferior aesthetics and veiled accusations of laziness behind adjectives such as "didactic," "heavy-handed," and "too timely." Black people kept getting shot. *Citizen* became a first-year commons text.

Over it: Juanita (Ketty Lester) in *Blacula*.

•

13. Guitarist Munky says the band knew live audiences would "fucking lose their shit" at the song's surprise breakdown. Producer Toby Wright follows, "Back then, the crowd bounce was a big thing. If that crowd wasn't bouncing, you weren't doing your job on stage." Mashurov, "The Definitive Oral History of Korn's 'Freak on a Leash.'"

Blacula too has/is a problem of capacity. If few critical readings of the film contend with it as a product intended to capitalize on identificatory gestures, fewer still take an overall inventory of its formal desire to pimp representation for viewer gratification—beyond the point of generic excess as centrifuge for its textual commitment to compulsive and contradicting identi-fictions—unto representative futility, such that the semiotic interface *Blacula* proposes veritably self-destructs on one hand (not unlike its titular antihero), creating on the other an entropic reflection of enduring representational crisis. . . . Sorry. I mean I find it an interesting mess of unreality, so full of fake shit it accidentally says some real things—which makes it not unpoetic in function. In a historicist approach to the film text, acknowledging its many referential prompts for various historical analyses, Leerom Medovoi considers *Blacula* "a film whose ideological import is not easily determined," a film that continues to acquire new sociopolitical meaning—most immediately, for Medovoi, in the aftermath of the 1992 Los Angeles uprisings.[14] Taking into account the temporal and cultural-memorial proximity of *Blacula*'s 1972 release to the 1965 Watts riots, Medovoi gradually records the limitations of comparably less complex theoretical models before arriving at a kind of *representation theory* that (if I read it correctly, and I mean, shit) strives to account for how Blaxploitation film imagery in particular works in conversation with and comments upon an overall landscape of cinematic text that traditionally fails to recognize or outright represses the historical relations of Black people.[15]

14. Medovoi, "Theorizing Historicity, or the Many Meanings of Blacula," *Screen*, Vol. 39, Issue 1 (Spring 1998), p. 3, https://doi.org/10.1093/screen/39.1.1.

15. Against leaning into "Black imagery" versus "imagery of Black people," I want this particularity to account for how Blaxploitation filmmaking's typifying trait was to maintain a loose commitment to both, employing (scapegoat) Black creators to construct (white-owned) studio-controlled images of Black people. I make no attempt to revisit those critical efforts to distinguish Black cinema from cinema involving/regarding Black people, or synonymous tensions taken up by Robin Means Coleman ("*Black* Horror Films [vs. Blacks *in* Horror Films]"), Thomas Cripps (*Black Film as Genre*) as cited by Tommy L. Lott, and others. See Means Coleman, *Horror Noire* (New York: Rutledge, 2011), p. 7, and Lott, "A No-Theory Theory of Contemporary Black Cinema," *Black American Literature Forum*, Vol. 25, No. 2, Black Film Issue (Summer, 1991), p. 221–236.

Nevertheless, it can be argued that most historically minded critics have continued to pursue a variant of Lukacsian criticism by invoking the term 'representation' as an alternative to 'reflection' that seems to escape the latter's inadequacies. If reflection demands a relation of verisimilitude and realism between text and history, one that is deeply fixated on iconic and metaphoric forms of signification based on principles of similarity, representation points more broadly to a referential function of the text, one that might operate according to other semiological principles such as the indexical or symbolic, the metonymic or synecdochic.[16]

Blaxploitation cycle films like *Blacula* were made to enjoy lucrative runs in predominantly Black "urban center" theaters frequented by youth audiences, as Ed Guerrero observes in *Framing Blackness*,[17] situating them as not-at-all passive operators of the above "semiological principles" but rather significant, *signifying* actors in the imagistic landscape, exerting force within their respective systems of visual grammar and cultural production. They are cultural products that help reproduce culture, that is. The success indicated by the rapid production of its 1973 sequel, *Scream Blacula Scream*, starring Pam Grier, as well as its numerous imitators, makes *Blacula*'s messy and pandering mass appeal pertinent to understanding how media capitalists sample, revise, and regurgitate popular discourse in order to control the cohesion and inertia of ideological formations. Medovoi's interrogating *Blacula*'s trading in ideology doesn't endeavor far enough beyond the tensions between protagonists Mamuwalde aka Blacula, his beloved Tina fka Luva, the scientific-investigator-turned-vampire hunter Dr. Gordon Thomas, his boss Lt. Detective Jack Peters, and the generic and historic symbolism each offers in relation to the others. Skirting their central conflict are those who would likewise be the analogous site of ideology: the regular "hoi polloi," the extraneous characters, among whom the protagonists

16. Medovoi, "Theorizing Historicity," p. 6.
17. Medovoi, "Theorizing Historicity," p. 13–14.

struggle for narrative authority, and who are situated as both the casualties and co-conspirators in those struggles. Understanding ideology as definitively a system of social doctrine, I want to pay attention to these characters who eventually constitute the social sphere—the first persons plural on either side of the contradiction that is Mamuwalde, the classic, charismatic, eloquent, lovesick, proud Africanist nobility literally fixed in history by occult origin, *vs.* Dr. Thomas, the modern, scientific, suburb-aspirational, tight-lipped public servant adjacent to, yet mobile within, the white institution.

But first, remember that generic excess I mentioned? *Blacula* conflates the aesthetic referents and narrative forms of tragic drama, Gothic horror, the creature feature, and Blaxploitation crime thriller.

Blacula as Tragic Drama

Count Dracula curses Mamuwalde to thirst for eternity in the confines of a coffin, leaving his princess Luva to mourn in his dark tomb, "helpless and dying, until the black flesh rots from [her] bones." A century later, Mamuwalde finds Luva reincarnated in Tina, whom he first glimpses through a curtain at an open-casket funeral. Their star-crossed union meets its ruin in the third act by a conjunction of human error and the culmination of his parallel agonistic union with Thomas, ending with Tina staked through the heart in a coffin. Mamuwalde, heartbroken, destroys himself by climbing into direct sunlight. His skin burns away in a jarring sequence of dissolves.

Blacula as Gothic Horror

As much as he is motivated by this amorous urge and, in his pursuit of Tina, dares to engage the perplexing social customs of the world into which he emerged not two days ago, Mamuwalde likewise moves and behooves according to a bloodthirst that transforms him in both manner (sans speech, he growls in kill scenes) and physical appearance. This latter

urge externalizes his monstrosity,[18] and affirms the doom of his double life—a limbo in which he is constantly in divagation: away from love or away from blood.

Blacula as Creature Feature

Thomas, a science officer and government agent, investigates and hopes to stem the tide of Mamuwalde's out-of-control vampirism pathogen. "Vampires multiply geometrically," he matter-of-factly warns his superior. He also wants to prevent Tina's coupling with this inhuman figure.[19] The climactic confrontation finds Mamuwalde most potently violent in a subterranean chemical plant. In campy sorrow at Tina's demise, Mamuwalde refers to himself in the third person as a "cursed creature." He dies and the science gun is victorious.

Crucial to note is that these generic forms cooperate, they emphasize and clarify one another. Blaxploitation's sexual excess laughs at Gothic horror's prudeness. Tragic drama's cyclicality makes the crude linearity of the creature feature cool. Yes, I'm being a little paraliptical.

18. S/o Douglas Kearney, again, this time for his reading of monstrous appearance as demonstrative rather than determinative—in his case, of lycanthropy: "Should we take *human* and *wolf* as syntactic subjects, we have the start of our werewolf metamorphosis logistic. I must insist that we consider this, again, as an *externalized aspect*. A werewolf isn't a werewolf when they are hairy and clawed. They are a werewolf *because* they can become hairy and clawed. The metamorphosis or transformation, then, is not *becoming a werewolf*. It is a demonstration of their lycanthropic nature, often commanded without any agency on the werewolf's part." Kearney, "#WEREWOLFGOALS," presented by the Bagley Wright Lecture Series in Poetry and Washington University in St. Louis, October 8, 2020.

19. This carries over the miscegenation anxieties that marked classical creature features of the mid-twentieth century. In *Horror Noire*, Means Coleman offers a summary history of coded Blackness in the subgenre, with *Creature from the Black Lagoon* (1954) contextualized in the same image system as Emmett Till's murder in 1955. Adilifu Nama offers detailed engagements with sci-fi/horror monsters as symbolic dialogue with various points of racial discourse, including purity and contamination, sexual excess and repression, and "post-racial" human coalition. Read Nama, *Black Space* (Austin: University of Texas Press, 2008).

Blacula as Blaxploitation Crime Thriller

Alright, lemme not be so redundant. In the seventies, William Crain pretty much only directed cop dramas, not limited to *Mod Squad, The Rookies,* and *Starsky and Hutch.*[20]

While Dr. Thomas is legible as a metonymic "long-arm of the law," Medovoi and subsequently Brooks Hefner accurately interpret him as effectively the lesser of the two Blaxploitation hero figures the film offers, even as he aesthetically invokes the cool of a *Shaft/Superfly* archetype.[21] Hefner, treating the film text as a "self-reflexive . . . autocritique" within Blaxploitation,[22] even proposes, in a shot-specific comparison, Thomas's characterization as a defamiliarizing version of John Shaft, a more overt "Tom" provided as commentary on Shaft's subtle alienation from the Black communities to which he superficially belongs, and illuminating Shaft's down-low deference to white hegemony.[23] As Thomas's contrary, then, Mamuwalde's figurative representation of an antiestablishment, Afrocentric radicalism grows gradually exaggerated, allowing his alignment with ungovernable Blackness, Medovoi observes.[24]

In one sequence, for example, Mamuwalde hovers emblematically over an intensifying scene of people refusing to go home. Though so well lit that his shadow against the wall behind him checks off easy homage to *Nosferatu,* he is out of sight yet seeing all, scowling. The cops have created a perimeter around Tina's apartment building and are threatening the crowd with a curfew, pressing them via megaphone to "cooperate by clearing the streets." Mamuwalde, being vampire, is curfew's ultimate invalidator.

20. Harry M. Benshoff, "Blaxploitation Horror: Generic Reappropriation or Reinscription?" *Cinema Journal,* Vol. 39, No. 2 (Winter, 2000), p. 31–50.

21. Medovoi, "Theorizing Historicity," p. 14.

22. Brooks E. Hefner, "Rethinking Blacula: Ideological Critique at the Intersection of Genres," *Journal of Popular Film and Television,* Vol. 40, Issue 2, p. 62–64, https://doi.org/10.1080/01956051.2011.620038.

23. Ibid., p. 68–70.

24. Medovoi, "Theorizing Historicity," p. 17.

Right about here, these critical readings of *Blacula* get it fucked up; understandably so, given that the social choreographies they grapple with remain elusive vehicles of dissonance (e.g., Tyler Perry = #everybodyblack, Obama as savior & drone-bombing deporter-in-chief). In the sequence I describe above, cops have blocked Mamuwalde's usual access to Tina, frustrating him. Neither Medovoi nor Hefner, in inquiring after ideological intersection in *Blacula,* interrogate the representative potential of the sequence immediately following in which Mamuwalde, suddenly and without narrative precedent, telepathically summons Tina to him after having previously declared that she "must come to him freely, with love, or not at all," and promised not to abduct her. This boundary is necessary to articulate, perhaps, because Mamuwalde's mo *is* to violently assault and abduct. Consent is no factor in his creation of new vampires, which runs counter to Hefner's proposition that, based on the inclusion of the gay interracial couple he first killed and because he loves his woman, Mamuwalde's victims-turned-vampires are less minions than the intentional creation of a counterpublic "community of the oppressed, composed almost exclusively of African Americans."[25] (It is twenty years until Candyman terrorizes everybody Black in Cabrini Green.) Vampirism, which manifests in Mamuwalde's victims as alingual primacy and automatism, is the explicit condition of Dracula's enslavement of Mamuwalde; to read it as a conscious coalition either dramatically revises or utterly erases the expositional exertion of his autonomously approaching Dracula to seek the cessation of the Atlantic slave trade.

Furthermore, Mamuwalde does not care.

[Here, as elsewhere in this lecture, was a film clip that won't transition to hard copy publication. (The fuck are tech billionaires supposed to be for?) In this clip, Tina asks Mamuwalde what he intended to prove by having, as a centuries-old vampire, done something rash and probably destroyed lives and un-deaths. "They mean nothing to me," he asserts.

25. Hefner, "Rethinking *Blacula*," p. 67.

"No one matters but you." This makes Tina's eyes all doe-like as she blinks up at him.]

Before the sequel, he is neither paternal toward nor affected by the demise of his horde. He does not choose them except by circumstance; most of them were in his way. Hefner's reading the horde as a radical coalition fails to acknowledge that *Blacula*'s attention to conventions of Blaxploitation, and its enactments of cultural fantasy, is simultaneous to and *mediated by* its attention to conventions of horror, particularly vampire horror, in which the compositional motivations of creator vampires are regularly characterized by how they relate to the created. The many cinematic iterations of Dracula's pursuit of iterations of Mina (or Jonathan), for instance, while having next to no regard for his wives, is not Max's and David's desire to Brady-Bunch a vampire family in *The Lost Boys*, which is not Louis's agonized parental rage after Claudia's execution in *Interview with the Vampire* (nor Akasha's massacre of whole covens for sport on her way to consort with Lestat in *Queen of the Damned*, for that matter), and none of which is Deacon Frost's secretly keeping Blade's mother as a lover and eventual bait to cage her son for a blood ritual. Somewhere on this spectrum of vampire relations with varying degrees of sophistication, Mamuwalde seems to recklessly create conscienceless ghouls according to no design but his thirst and proximity. Twilight Saga vampires have more intention.

Reading the accumulation of meaning in the images of death and undeath in *Night of the Living Dead* (1968) and *Candyman* (1992) alongside those of lynching victims, Jessica Baker Kee concludes that the "overly familiar narrative schema" imposed upon the imagery of abjected (grotesque, composite, unruly) bodies continually produced and recycled in US visual culture tends to foreclose unfamiliar and "unbearable meaning(s)."[26]

26. Baker Kee, "Black Masculinities and Postmodern Horror: Race, Gender, and Abjection," *Visual Culture & Gender*, Vol. 10 (2015), p. 47–56.

To read the genre's zombies and ghouls as stand-ins for particular abjected identities is to ignore their positioning at the ambiguous boundaries of representation. . . . As cultural border objects existing at the uncanny intersections of life and death, these corpses offer the possibility to ethically interrogate the ways our visual culture confirms or denies particular identities as worthy of attention, empathy, dignity, and even life itself.[27]

While I agree that horror's regular invocation of these "ambiguous boundaries" offers viewers an expansive field to test the persistent instability of identity, I would like to provide that neither the production of a corpse nor the ghoulish deprivation of all autonomy in the living is a required occasion to reconsider representation (of identity) as an overdetermined— and inevitably violent—syntax of social formation.

Tell me how a charismatic brother with a cult following makes a revolutionary.

That's deputization.

A cult is cops.

The cops in *Blacula* discover the vampire horde in their antique-warehouse hovel and, not without trouble, dispatch them with stakes and oil lamps. (Thomas does most of the work, throwing his body around as Peters's human shield. Three years after Stonewall, a cop film can only endorse the interracial homosexual couple that is state and masc. *In the heat of the night.*) The warehouse goes up in flames, conveniently just before Mamuwalde flies in with a flourish of his cape and a flicker of humor. That princes only dream of kingdoms is a meaning one might have to bear.

27. Baker Kee, "Black Masculinities," p. 54.

By the same token (big pun), Medovoi apprehends in Mamuwalde an appetizing capacity for the audience to identify. In the first scene, Luva's single utterance of a full sentence is to describe him as "the crystallization of our people's pride." This moment seems to set in motion an anticipation in the film text that the viewer will commit to evaluate not *who people* or *what characteristics are without the people's pride*, but *how* the statement remains true subjected to Mamuwalde's vampirism, leaving other concerns secondary.

> If as Mamuwalde the African prince he embodies an untainted, black cultural heritage, as Blacula the vampire he is a bloodthirsty creature who preys upon the black community of Los Angeles. And if Blacula's representation of himself as Mamuwalde is seen as mere disguise, then the film might seem to accuse African-identified forms of black power with concealing a desire for violence that African-Americans themselves need to repudiate and contain, attractive as they might find it to be.[28]

I don't know what "untainted, black cultural heritage" would be, but I understand that it's within the purview of Blaxploitation's desperation to propose its existence. The contradictions Medovoi reads here as "ample room" are, of course, oversimplified. If I can offer that a historic, representational desire runs beneath them, then: it is not "disguise" but duality; it is not violence as end but as means to a form of ("back to Africa") virilocality, of the sort implied in Mamuwalde's proposal that Tina "rejoin" him. (The film makes no indication that Tina had any business of her own while presumably awaiting Mamuwalde to cross the oceans of time.) Diasporic melancholia was loud in seventies Afrocentrism,[29] and

28. Medovoi, "Theorizing Historicity," p. 13.

29. I'm using this term kind of retroactively and, if I'm being honest, rather loosely. It is conceived and defined by Sarah Clarke Kaplan, with regard to Julie Dash's 1991 film *Daughters of the Dust*, in the article "Souls at the Crossroads, Africans on the Water: The Politics of Diasporic Melancholia," *Callaloo*, Vol. 30, No. 2, "Callaloo" and the Cultures and Letters of the Black Diaspora: A Special Thirtieth Anniversary Issue (Spring, 2007), p. 511–52, https://www.jstor.org/stable/30129761.

for white-powered Hollywood to have appropriated its inflections and refracted it for loose change is predictable. This "crystallization" is the provision of Blaxploitation by any other name, in any sociotemporal setting. Is capitalism not itself an apparatus for oversimplifying and replicating gainful mechanisms? Is its intent not to involve and consolidate? I'm a mess until you ask me how I'm doing; then I'm "okay" to keep it simple because I know you got somewhere to be.

·

I'm almost done, I swear.

I'm turning, flipping through Renee Gladman's *Calamities*, wondering if I'd unwittingly underlined mostly moments in which Gladman is concerned with the failure of deixis to really reconcile containment and the person, or if those moments predominate the text. . . . Yes. "She wanted to walk into a word and then into another word and another and keep walking . . ."[30] Copying this in my notes I wrote *a nother* instead of *another* or even *an other* and I think I mean that thing. Returning to Baker Kee's "accumulation of meanings" (via Sara Ahmed's "associations over time . . . make it readable as Black in the first place," and Fanon's "epidermalization"),[31] I begin to feel (contemporary?) life as an ambulation inside of gesturally conceited language, as if in a Nick Cave Soundsuit,[32] except not nearly as affectively elsewhere and forthcoming; in fact, an anti-Soundsuit—closer, then, to the Post-it suit on the poster for *Office Space* (1999), if the Post-its were news clippings, which hardly exist anymore.

30. Renee Gladman, *Calamities* (New York: Wave Books, 2016), p.58.

31. Baker Kee, "Black Masculinities," p. 48.

32. "Nick Cave's best-known work is the *Soundsuits* series, costumes that completely cover the individual's body. They camouflage the wearer's shape, enveloping and creating a second skin that hides gender, race, and class, thus compelling the audience to watch without judgment." "Nick Cave's Soundsuit Sculptures – Everything You Need to Know," https://publicdelivery.org/nick-cave-soundsuits/.

When I tire of talking, I ask "rhetorically," how have I not been saying what I've been saying? I ask myself

because how can I have been saying it if I'm still having to say? This -*ness* mess, my shitty mood of -*hood*. I've made it my business to struggle repeatedly, insanely, in the pursuit of a specificity of feeling, of thought; that is, never to get there, never to get right, but anyway going. I'm sorry, but I don't want to remake Africa in your image, friend. I am interested in a homemaking that facilitates the incoherence, the psychospatial need to grow and mature into the shit I don't know, the shit that is possible to un-know, and the impossibly known. *Which is to say* (look how I make me speak to reach out) that forced social configuration based in a pretense of *knowing* the unknowable (delineations/delimitations of Blackness) really confounds me. To say "I see you" is not to suggest you've hit a marker of recognition in my extent theory/worldview. Rather, I see the expanse and that you open to it in ways prepositionally indeterminate. More under- lined Gladman:

there is the fact that space has changed, that history has been opened (this line came from the past). "It opens," and I said "it" entirely without knowing to what it referred. We sometimes say it when we don't know or when we have gotten lost syntactically. (123)

What it do and here it go. Can "it" even open if I know to what precisely it refers? Why do I epitomize? Why do I act like I have no idea where epitome ends and thus entertain a canon of Black poetry or a canonicity of Blackness as arbitrated by people paid to say so? To rehearse this program in the marketplace of capitalism's thirsty-ass matrix, which is declaratively invested in the reproduction of a *knowable* Blackness? Pointedly signifying—pointing *at*—how black this black thing is, so that it may be found serviceable wherever it may be found, is to be definitively an interlocutor about the definitively vernacular,[33] is to fix it in time-space, is to pronounce its social death, is "a prison; it disregards the uncustomary things about you." (Gunn, again.) Sometimes, in my mostly monolingual existence, I have the nerve to insist on the sacred accessibility of some regional dialect of Black English qua *Blackness,* but then I sit up and listen. Canon is against possibility. It means to be definitive, complete, nation. It is already closed and always trying to catch up to closure. So what are you saying? And I said I wouldn't do this.

Here is a probably problematic excerption of Simone White's essay "Dear Angel of Death"—the problem being that I don't think White's record of deep life among source material lends itself without some punishment to representative excerpt—likely it works against the impulse—and I risk admitting here to an absolute misreading.[34] But representation is not my intent, and more likely misreading is requisite to any other reading.

33. The first or second dictionary sense of the noun *interlocutor* is of minstrelsy: a middle-man. See https://www.merriam-webster.com/dictionary/interlocutor. The Latin root of *vernacular* refers to a "native-born slave."
34. Simone White, "Dear Angel of Death," *Dear Angel of Death* (Brooklyn: Ugly Duckling Presse, 2018), p. 67–150.

(After a hard time, I'm coming around to the idea that, in relating an engagement with a text, total comprehension is unnecessary. Some measure of proficiency, on the other hand . . .)

And no: a logic that makes it possible to say "African traditions of expressivity" as if, specifically in relation to aesthetic practices that have come to be identified with local varieties of New World blackness (at any of the several levels at which such a thing might be said to exist . . .), when straining to represent the African, modernity breaks out inside a person; the modern, the black inside a person breaks things, and that breakage becomes the signal of the necessity of breaking that expresses the tie to Africa.

It is not easy to talk about what happens to a person immersed in black culture and life . . . to whom the reality of black difference is undeniable (where claiming that black difference is real is also a claim about *orientation*, and also a claim about the way things come to be known) when explanations of blackness' overdetermination appear to come apart at the seam along which everyone agrees the logic of blackness, which cannot be said to be any one thing except originating with the idea of the value of the "African," shall cohere. (White, 91–92)

Sometimes I am (in) the room, sometimes the breakout room, and sometimes neither congeals. What I call "room" is an effect of contingency (the chance conditions), and the contingent (the people situated by the conditions) precedes the room, though I speak as if the inverse were true, as if the room makes the people. Sometimes I project the room ahead of me like a helmet light; I step and it moves, and I keep trying to step to and from it.

The dynamism of the lived experience of the black, as she turns this way and that in relation to this and that in relation to larger spaces in which she is materially constrained, is analogous to that which is "on the way," to the extent that black human being is, also, on its way. (White, 95)

This last note, I think, is what that word *futurity* can refer to.

You know, this might be a futile exercise after all. I've gotten ahead of myself by forgetting how far behind "Dear Angel of Death" I trail, wheezy and, as I've been called, slovenly. But it feels crucial to put down—before I pick up and go—a bit of White's extension of Fred Moten's Black surrounds and "delightful . . . agnostic[ism] about the delineation of a boundary," as I can only, barely, read Moten by citation.[35]

> Blackness is its own place, always next to the place where place is thought to begin, whose inside is knowledge of the falseness of, *the defiance of,* enclosure.
>
> [. . .][36]
>
> The covenant that makes our "thing" a thing that can be apprehended is the promise to stay together in the absurd or "foolish" space of the self that accepts itself as black, surrounds itself with blacks, a promise that is made and renewed by a self in "constant improvisational contact" with other facets of the world. (White, 125)

"Constant improvisational contact" is that contingent (persons) in contingence (touch) via contingency (dependent on circumstance). I'm letting this go on because there is somewhere I want to get . . .

> blackness is a thing whose inherence is partially concealed by the horror that (presently) envelops it.
>
> The black is outside time/the black is outside space? How can this be, even if the black is recorded as outside ontology or constructed as a remnant in the language of language so that she is inconceivable

35. Ibid., p. 124–125.

36. Inside this ellipse is actually an opening where White calls "our thing" "subcenobitic," which sent me after the Cenobites of *Hellraiser* (1987), a squad of kink demons who hold and twirl the line between hell and earth, between pain and pleasure, who mark a principal betweenness that isn't the Black betweenness White is playing with/ for, but, within horror's play of "uncanny intersections," is not *not.*

in the face of her gore? Here I am, *we are here together*, inside this time-space together. The desire to eradicate me from the frame cannot accomplish its object completely; therefore the total eradication from being of the black is, by definition, a total failure. (White, 129)

I'll give in to White's first person plural for the sake of argument: *we* is an argument. *We are here together*, in a constructed *here*, an LED-projected here, a nonspace that is also many spaces attempting to cohere, a nexus of representation and of identification. We allow ourselves to be thus represented in a very first sense of the *virtual*, "being something *in practice* . . . in effect even if not in reality or not conforming to the generally accepted definition of the term."[37] This practice/promise/premise also includes, currently, our construing simultaneity: interpreting our individual nonce times as being and conveying the same, or sufficiently similar with accepted lag. White's "Here I am" is, I think, akin to Claudia Rankine's "I am here," which "both recognizes and demands recognition"[38] (as in my momma's *looka here*), lays plain the vulnerable position of presence, records you recording me and instantly then I am pinned in the record of how horrifically I come to be inside us. Thus us: the beginning. *(This line comes from the past.)* "We" "are" "here" not by generally accepted definition, facing our gore, practicing time-space/spacetime—few conventional deployments of which have not tried to encage and incapacitate us.

How I, here (submitting to the conditions of this *here*), yield to you is something about how I yearn to be known in a grownness of existence, a dream of being Black in the *next* place, out from under this non-Soundsuit, this paper trail.

37. Encarta World English Dictionary (New York: St. Martin's Press, 1999), p. 1984.
38. Claudia Rankine, *Don't Let Me Be Lonely* (Minneapolis: Graywolf Press, 2004), p. 130–131.

This modern world folds us together, envelops us in the color line and the discovery of blackness as rending itself, or gap, or inherence in the discovery of the true time: that which is possible at the level of the human at any given instant.[39]

How I have come to be here (emphasis wherever), endeavoring to be recognized by you, is nearly unspeakable because it is unknowable; I don't know all of wherefrom "I" even issues as it, too, has come to be representative and emissary according to the terms of devastation. So please, looka here / feel me when I say that my saying *I don't know you like that* is an acknowledgment of the(e) expanse. It is my resisting the excess of projected characterization that weds me to capital convenience and palimpsest (auto)biography. It is perhaps the sincerest form of care that I can personally offer here-now.

Now, here: from "Vanish in Our Sleep," the last few minutes of *Stretchin' Out in Bootsy's Rubber Band,* the there-then of Bootsy Collins:

If they could understand
The position they put us in
If we can only be real
About the way that we feel
Then we could fly away
To another time and space
We could love—we could love *love*—
In our own rejected way[40]

There go that *nother* again. That second conditional clause splitting the distance between the first and the whole hypothetical, the virtual, the practical: being "real" is closer to that time-space I wanna get to.

39. White, "Dear Angel of Death," p. 125.
40. 0:38–1:10 of the track. George Clinton and Bootsy Collins, "Vanish in Our Sleep," *Stretchin' Out in Bootsy's Rubber Band,* Warner Bros., 1976.

That *can* is not *could*. It is the only *can* around.

Bootsy and them already called-responded on this album, "If I never ever have to be phony for you / *We're gonna make it. We're gonna make it.*"[41]

I spent a lot of time faking it and forgot to make it.[42]

41. From "Another Point of View," *Stretchin' Out in Bootsy's Rubber Band.*
42. S/o Patti LaHelle and "Dionne Warwick," *Got 2B Real.*

I BEGIN TO LIVE WITH *GANJA & HESS*

Thank god your horrors outweigh your manners.

We are not permitted the image of his visage above an empty noose.

I've mentioned to you previously the etiquette of lamps.

When the night is this heavy, you have to straddle it.

I am the only horse on the block. Trotting up to my house is a trick I was taught.

I'm proficient in the language of trespass. "My tree." "My rope."

I get to elope with empire & use words like *hope.*

Deleuze remarks that such devices as the director's self-decapitation in this frame suggest a "trans-spatial & spiritual whole . . . outside homogenous space & time."

Together in their twin outfits, the bisections of Hess & Meda make one suicide. In *Night of the Living Dead,* Jones wore this getup to his lynching.

The noose hangs like ego. Bulb of a man's idea. Brief as the sun.

But the mind is as wide as the night, which is the return of eternity.

You cannot adequately light a black thought.

Western philosophy is a byproduct of slave labor.

I am able to hear myself think either by way of rebellion or because one is being suppressed.

"I was a victim, on one hand, & on the other hand, I was a murderer."

Thank God for horrors.

What conditions make possible this poetry?

The truth of the thing

I love you. You floor me. I have loved you and been floored. I fell
for you. I hit the floor. I'm in love and on the floor. Blood continues
hitting the tiles. It glides over grout. It slides out a mouth that
I made in my head, having loved you in a way hardly regular. It
is as red as a convertible, Christ's robe at supper. I don't know
why I think love looks like somebody on a floor, or a dinner table
broken in two, or a fist where fits the grip of a pistol I haven't yet
faced in person, though I know a man who loves me has for me one
or the other. Yes, I'm thinking of my brother, whom I've bled—
what he owes me. I always got my ass whooped in bathrooms. You
remind me of him, and quietly I like it. One of you will destroy me.
Anonymous gospel will open in the shape of a horn in an off-camera
corner of the room. Open as the mouth on the floor, blood thick
from a spigot. Spill of magnesia milk. Thick wad of wasp larvae,
the spider's open abdomen. Red as the bone of an aesthete.
I love you to the floor.

So we got three things going. We got some grape jelly, some hominy grits, and an extension cord.

Frequently people be impressed with some shit that I did that isn't impressive
 For three hours a week, my nana in her usher uniform
 People like to fabricate nouns so white you can't work in them
 No one rouged her cheek, none ran her or her stockings
 Like *publishing*
 Or stepped on her tennis shoes, sweated her lapel
 A cloth I have to launder once I wipe
 my face has no stamina
 Her man was dead or not your business
I come to the table up, washed like I already ate, painted like I already
 slaughtered
 Baking soda somewhere seething among my bequests
 Frequently people mean to look like (that's they) money
 Framed by a wicker-back I'm spooning
 Bleach and *black* share an etymological base
 sugar sheer as pestled glass from stainless
 Spent hours cleaning out, daydreaming cresting waves
Stayed knives of a starched collar, whole moons stuck in the lobes of
 By the time we make love I'm exhausted and starving
A stunning lover
 A contrived still life
 Who fingers cherry entrails
 With hive of muscadines
 While two thick peaches cleave to their pits
 And six-piece bone china set
 A set designed
 Daisies spectate from a standing planter box
 Xs and checkers
 of decadence rebranded as evident style suggest
 Sprays of metal petals, unwilting
 color happens at crossings

Madam, I came with the house
If you burnished all this we'd have a different conversation
I mean shit I could go with it too

And I loathed my beauty for that.

this was always sposed to be a story of carnage. copper stripped from
a basement. walls barged down the river, ruddy as the stain on the
sister's seat. that day in the rain & the frame still smoking. in the
chain-link fence's revenge, it split her sole. rust grit & brick dust
gripped in her prints. brush hisses in dense brown hush. horseshoe
kicks what you tryna say (trap shut.) into

snowbank the cricket twinkle renders. bring in the big evening.
in its black continuity, we are outnumbered & maneuvered by
memory.

her beauty excruciates, emphasizes the cardinally directed reflections
affixed to Marlene Clark's face. we stop the motion of molten metal
& beg it, frozen, reveal us intrinsically. the child born (e.g., Rosso),
as creation, is a solicited solidification of interior crisis, a temporary
& meaningful clot. someone chooses ruin for the wood. from that
shot to this, both a cross cut & rip cut in which classical sculpture is
an anachronism & a parallel becoming:[1]

grave(n) woman / "wonderful girl." "barbie doll," the father calls
the mother's portrait: blush background, collarbones, curls, tinted
lip. easy, the sands of his pharynx romance: waterfall, rose furls,
cinnamon stick. this blood coupling's

a because of me, its symmetry & fuckery. thou art with me & once
fine & ordinarily poured your good years into systems of profit,
piecemeal pocketbooking stolen feed. grief, grief, relentless thrift.
you suffocating burgundy apology.

1. Gunn blackens "Western" time, or Gunn restores flux to the Real amid a fabrica-
tion of narrative etiology.

You know I want you to live forever

don't mean you owe me something to live for.

The longer you endure against death the more
acutely the finitude of your tapering life agonizes me.
You know it. What makes me vampire isn't courage.
Just teeth, tight stomach, cologne
of old money, & I'm sturdy when I lie.

I planted myself on the lap of an elm facing west
at sunset. I pressed
my dirt-blessed palm to its mossy knee
& brushed more black into green.
A redtail stretched through the cathedral's silhouette,
landed on a limb, blazoned the arrogant amphora
of its bigass chest, & fastened
the day down to a portrait.

Earnest in my mind, I would've liked to die
seated in this theatre of evening,
real cinema rimming me orphic,

courting the petition to ignore it:
cops who prowl the cruising loop & drag
the border in, buses transporting Giant Eagle employees
up this unaffordable hill, even the clearing
cleared of stumps & twigs & material excess
& evidence of ending's incessant recurrence.

Life here is terrific work. Immortal—
gorgeous, bored, subsisting on gore—
I'm married to unworried words. I make snake charms
that speculate you. I paint you
maintained landscapes where nothing aches
or has hands.

No, I mean I really want you to live forever.

 with thanks to Tongo

Whoever looted these acres where I muse
lorded the bird's-eyed horizon & challenged
your peasant spine to catapult feelings
of human being beyond his walls. Then came
the advent of philanthropy. In anthropology
I defer to a study of people that means to exceed
people. It's poetic that way: it can make an AR-15
a metaphor for a poor boy. He has rights
to missing limbs, parking lots, executive arms.
You were once a people farm. You had a heart
hacked into the likeness of a terrorist
on horseback. I came, I cut that heart out
& I named you City Park. Some days
I'm reminded to adore you as though you are
bones on display, or selected poems.
The state of our union is debased & alone.
You can tell from its tone that this poem intends
to outlive both of us & we are energized
to give up a good, long life to literature
in this hemisphere, yet here you are still
believing we're in any condition to literally
love. I vomit back into the gullet of
a university reports from the front of a struggle
it wants, violence it maintains like its own
police force. Would bacon ever bring *you* home?
What shimmers in humors of lachrymator agents
is job security, mirage of exhaustive categories
of first Black capitalists. On earth, we briefly
thought the way out was off the earth.
I thought the way was through radical academic
self-help. I protest; I fail to disperse until

the lawyer professes I am a professor,
have professional successes & publication credit
freedom papers. At graduate commencement, we
decree my decommissioning. Let's call it
a Persephone schism. It isn't sexy
when I wear my amnesia & assorted fatigues.
When we come to the end of this innocence
tenure, my love, let me blaze into bloodthirst
& sleep in my dirt. Forever is a nervous
disorder & cavernous discipline: Retire
& it rots you. Resign & they bill you
& it will continue. Premature death's
a true national debt. I put my whole life in my mouth
for money that heads to the landlords & feds
on schedule, so it pays me to tell you
more elaborate lies: I want you to live a forever
in this museum of our unmaking,
guarding the perimeter of extinction-witness industry,
lunching in the coffee shop on your mom's old block
serving egg bites & seasonal flavors of tasers.
Everywhere you used to go to church, it hurts.
After all this, I must think prayer works,
I just don't feel like anyone who makes me buy time
isn't killing me to sell me what's already mine.

But the cross is only an implement of torture. Its shadow is the darkness it casts, you see. Nothing can survive the shadows.

Shadows come in crews. Consider Solé in '99 in three light designs, six fans spinning 36 blades. A cut to her cuts her slim figure-8 into several Xs. WHODAT? Seven *I*s, twice, as in a sonnet of first-person assertion, the self ever forthcoming & possible; or a ballad stanza couplet of "aye" as in agreement (the official affirmation of crews of real crooks in congress, but here), a fourteener of *fuckwimme* that is also *fuck outta here with that.* WHODAT? JT Money making money & love synonymous from fake & sophisticated restraints:

this is how I found copsplus.com & could BUY NOW Smith & Wesson double-locking, nickel-plated handcuffs for 20 dollars. If he hollers, let him breathe less loudly. Knuckles & nuts shadow me. Their badges signify a butterfinger & lazy eyes. I graduated from bullies to bullies with taxpayer backing & pensions. I put this psychological crisis of cringing at endless pursuit into a concrete poem the people thought was dark but fun. The darkness / The it / The castes in crosshairs I'm persuaded to reiterate for people who don't mix concrete & poetry can best be allegorized by what lurked on all surfaces that children with markers could find in the nineties: Möbius strips drawn out of six vertical bars & their shadows. My lyric involutes with my brain matter. In the myth, the labyrinth was essentially a prison. Imagine the US allowing my mind to imagine life without it. All I do is think about you. I stick like a down-ass chick.

From "Who Dat" to "Who We Be," what interests me is the consistent thrash of limbs against context. X's restless body, refusing to comply with the stasis of a cell, breaks monotony into montage. His litany upsets the limits of the frame. But is he chanting "dead end" or what? while seven children, blue & grayscale as the "us" Michael choruses "they don't really care about," each declare "I am DMX." I I I I I I I sing myself into the melismas K-Ci makes of the words "land" & "country" in a video where him & JoJo, in shiny leather & fish-eye

shades, shuffle from bunk to block—everything the light touches
flooding them in a motif of police presence. How the brothers end up
crooning on the roof in suits has me asking if Black people's panoptic
self-consciousness, born of coming into being under perpetual
surveillance, manifests in these visual emphases on omnipresence.

I was raised to believe that God & my dead daddy were always
watching. How does a Black expat? On this Möbius strip, empire & I
try to figure which of us is captive to the other, & neither grows up.

Down at the cross stood more crosses. Out of a jackal came Damien.
"The snake, the rat, the cat, the dog. How you gone see em if you living
in a fog?" Shadows emerge in mobs. I mean, far from barbecuing the
swine in my mind, I'm still draggin the red wagon in which rattle my
uncles' knuckles, their gold cuspids, their brass tacks, nuts & bolts,
their cars on cinder block, the ropes they show, the concrete they pour,
how their women pay. The days spread out with the chocolates in
our little pockets til there was no shortage of grown-ass men holding
fistfuls of formless dreams & aluminum foil. In the shape of my life a
stray dog tugs a radio flyer piled high with a bastard

who removes a leather belt in perpetuity. The belt
is irreducible. It is also the leash. The animal
really gives a damn. The man's just good with his hands.

The crew in me accrues the crew in him, as well as
the deputy who tailed them & the confederacy
of foreman who boyed them the daylong before,

their fathers before them. All at least six feet.
In the six-month Carolina summer, their shadows
atop gravel lots at cookouts resemble drainage

where the got-loose dog was curb-popped & left to bloat.
They risk permanent damage when observed with the naked eye.

he said, meaning Let us be free of our fealty to blood
but not of each other. I said
Nothing. The lamp sway shivered my indecision.
The lamp light vivified my shadows. I noted
things about the room around us
—inventory of our belonging,
random & wrong & quitless
like skin tags. Bookshelves held up
the walls. The coffee table upheld
more books on its legs; the mortal lives behind the word
woodwork; the next-to-nothing we spent for those
spent years. When everything here eventually
gave out, we got more. Innovations
like the cigarette & the percolator
competed to keep our minds inventive, productive
as mines & one-trick fields
& same-fated farmers paid a fraction
of a tractor. To track these intakes down rows
of a pedigreed European auto stock corporation notebook
legitimized manuscripts that were otherwise mine
but, for archivists in the failing universities of the future
who own my dead papers,
harder on the eyes. As for love,
I knew I longed to be valued
in such a way as to watch his hands
atrophy & petrify, reluctant to degrade
my image of self-sufficiency. It cost too much
to be among the state's estate as long as I would live
to have nobody give a little, if just a damn
that today I ambulated; or imagine me
bathing, submerged to the shoulders
& disaccustomed to thirst
for clean water. Please, please, he repeated. Begging

hounded by its echo. A voice was singing the spirit
he figured he'd recovered.
He got up to get free. He stood up
to leave me. I hovered like the shadow
crossing his heart, saying Nothing. Suddenly he
was such a man (manpower
surrounded me), with his new leaves & physical uncertainties
he was outfitted to risk
while the memory of feeling cold
knitted my skin. The wind came in
& leaves turned over leaves alit upon
his body / one of the bodies he'd chosen I closed it:
to leave. the eyes,
 the hole in the ground,
my mouth, the door. What opened:
the decanter, the window, the
surface of water, my hand &
another body leapt over another rushing in.

THREE IN 2010

Patrick Wilson's ass. American angelic. In memory of Patrick Wilson's hairline. In any hot dad is the hand of an old man who wants me dead. Every other brand of old man in America is left for dead but the mad ones. The state of Florida doesn't just happen. In the years shortly before I let future Trump voters fuck, I barely know my father & am sniffing his boxers. The camera moves like eyes behind me in a room. Into the Further I go to find my father when he ghosts me. The Further is all of my secrets animated in simultaneity. Or the Further is one decade of extrajudicial murders concurring. With the lights out I feel dangerous but less stupid. In a dream my dead grandfather returns in need of a nap & promptly melts into a hot dad hookup the second he hits my sheets. The walls start leaking sewage & my apartment falls apart. Even my dead grandfather is tired of the bullshit I make my bed. The ruby door in the dark belongs to an F-150 in a field in December, where a volunteer fireman rawdogs me at fourteen. Fogged mirrors lose grip on a spitless moon. A closeted father & a lynching victim hover; only one vies for my body. My libido a denial I deny y'all. I'm not Ruby, I could never turn into Rose Byrne: I know all demons moonlight as my husbands & like it that way. By demons I mean ways I'm wedded to convenience, surveillance, & pleasures that enslave. How can it be quiet enough to hear disappeared children? The ghosts are contagious & immune to migration. Entertain us with the sounding haunts of fathers fucking. Instead of therapy, the AME church & lay hands on me, father god. With my father's fist in my chest & my brother's neck in my fists, I don't *turn* blue in any light. I also keep violets, devil's ivy, & mean reds: "it's not your house that's haunted, it's your son." It's not my country, it's my brain on my country. Your son is lost in a house so large there's someone in the baby's room before the security system squeals. Your son is lost in a system of kennels belonging to homeland security. The Further is the formative years of simultaneous animals we keep raising for a future we can't afford to survive. I had to die to escape the state of Florida one time. In a decade there were sequels for each finger you could slip in me & no way out.

The fuck is up with Shawn Ashmore & ice is also the fuck up with blue-eyed people & wolves. Ashmore has an identical twin. Caravaggio's *Narcissus* bends a blue knee. I think it's a knee. The root of "narcissus" is possibly the Greek *narke*, for "numbness." (See also "narcotic.") A ski resort & sundown town, same time. Picnicking in the carnivore park, rosé rude upon the powder, bones licked pure as the driven. White dads with blue eyes who work for endangered wolf centers hate this film & can't write *black* in killer-cop poems, they go for *poor*. If you root for everybody Black, relax; quote we don't quote do that. Winter Olympics. Except Sam Jackson in *Deep Blue Sea*, Harold Perrineau in *The Edge*: both dead. & on Saturday I biked to REI on the south side with a blue-eyed crush who speaks Patagonia & he is 6'3" & associates unbearably helpful to him, as if even with his discount they make well enough off the myth that there's anywhere to go in the city of Pittsburgh. Who tries to build a metropolis in a trailer park? Can I see myself in anyone from up here? Pissing to keep my legs alive in the air, falling in love the way tenebrism drags me kicking & screaming through winter. My eyes have adjusted to the illusion of set lighting. The drop is sheer & will crease my knees like earmarks. I'm right here; I never left to get help. I like his hand at my back in a $200 jacket. Don't fucking watch when it happens. I don't look long at the cheek of the youth but am mesmerized by the blue he will lose to the pool—his flash of taboo, attainable only this eternal once, tyrannically swelling enigmatic over time. The carnage is warranted in Caravaggio. Brushstroke of sun sloped through the fibrous cirrus over (& ergo *inside*) silver hip of Monongahela we pedaled the Hot Metal Bridge across,

& with fingertips stinging in my gloves, I wanted a hug.

You do not distinguish between turning to face a self & turning against it.

I want to be numb to the money in my name. Don't fuckin come looking for me.

I can't die where I don't even live.

Black pink. Cake nail. & camera dances it, too. Lights again. Slender women in unison, specific as wicks in the center. Aronofsky, Tchaikovsky, & the crunch of feathered necks between bootheel & permafrost. Glass caught in the breathing gauze, the bleeding gauze, the seething audience: *awe to you, awe to you.*

In the beginning of *The Rest of Love,* Carl Phillips opens his "Custom" with *There is a difference it used to make / seeing three swans in this versus four in that / quadrant of sky.* It's partly a footnote on disciplined study, attentive devotion as prison or road north. Pale princess of the quadrant of reticent labor, versus dark mistress of violence & leisure. The camera dances to compensate for imperfection in both.

Swan song: the black pink of vanities, electric daybreak. The specific splendor of sauntering waifs with cigarettes & Vincent Cassel. (Y'all just be casting men like whatthehell.) When Nina leaps out of labor into freedom, her violence blossoms.

Without drama, writes Phillips, *what is ritual?* The fingernail to Nina's skin
is Thomas's tongue in her mouth is
her mother at the keyhole is
Lily's face at her pelvis is
the something in her drink is
the nail file in Beth's face, over & over, is
the quill her rash surfaces is
the shard in her wound, flexing over & over. What is ritual? For the intrusion of suitors in unison; for the seventeen men who write, direct, & produce; for the mad queen painter who keeps her muse under lock & must be loved: cake & champagne for celebrations.

The night again. The light again. The light it didn't happen, Nina leaping out of Nina. But touches herself via hero plate, intimacy after green screen. Give her the Oscar for feeling distress at omens she can't even see on her

flesh. Race feeling, that's a hangnail. *They are everywhere to be found.* Black pink of sun setting & the silhouettes that liberate white women from their mirrors. "Melanin in feathers strengthens them against wear." We, oh, where? The weirdest sisters IRL, & there, when her neck stretches into rope.

Lose yourself to your dark contrary in the mise en abyme of conquest.

We think feeling is pink. Without black feeling, what is drama? Every genre of revelation is wearing my face. *I am not imagining.* I'm paying attention. What attention pays for has yet to be imagined.

LEISURE, LABOR, RETICENCE, VIOLENCE

presented to Bennington College, October 6, 2021

I have nothing useful to say to you concerning the craft of poetry. In this talk, I hope to relay to you nothing intended to be carried forth into the creation of poems, and especially not into the production of poetry that you could submit to the marketplace of contemporary literature.

I am not irreverent enough, however, to intentionally fail to deliver what I have been contracted to do: a talk or address concerning, not too remotely or subtly, the craft of poetry. But you should not expect utility from it. Helping others to write professional poetry that appeals to professional poets does not currently concern me, though this is, I gather, what *craft* denotes in the siloed environments of most creative writing degree programs, as elsewhere.

I have those degrees. I've sat through many of these craft lectures and been moved and bemused and bored. I remember how turned on I felt to learn the terms *hypotaxis* and *parataxis* at one such presentation, back when I geeked out about a palindrome's temperament for independent clauses. Regardless of my ardent or apathetic receptions, the craft talk, the reading, the Q&A, conferences, symposia, etc.—the general mass of this genre of engagement massages the pursuits and professions of the knowledge of writing enduring poetry. That's fine—as in the not-coarse mastery of an art.

But I wonder if what happens, if *one* thing that happens in this tandem tunnel-vision approach to fostering literary apprenticeship, even as we poets readily acknowledge our dialogues with other arts and disciplines, is the cemented insinuation that the creation of poetry—and the awareness of it, curiosity about it, reverence for it—is a conversation to be had preferably among poets, preferably through interactions that are lent the false legitimacy of ruling-class practices of scarcity and exclusion. And I wonder if it further insinuates that the insular, curated environs from

which this unassailable fine art continues to spring ought to be cultivated and kept at any cost.

Excuse me for spending this hour operating under the basic, belabored impression that universities in this country do persist in the tradition of being

extractive colonies that assimilate, deracinate, occupy, and displace groups of people

under the guise of cultural, scientific, and civic advancements

made necessary by the imperialist project upon which universities are a fairer façade

and made possible by meeting resistance with a reformist impulse, or concessions; by absorbing potentially radical thinking into endless bureaucratic labor that the institutions incentivize, meanwhile hoarding decent health care, pensions, libraries, creative resources, and leisure time.

As far as I can tell, having now studied poetry to some degree at a few institutions of higher education, the poems and the poetry pedagogy developed within universities rarely come to terms for these material conditions that—in not just forming the context of, but *facilitating*, creation—are also considerable elements of craft. The closest we seem to get in this regard is the specific rebellion against the strictures of the poetry writing workshop that draws attention, typically within a poem or thesis manuscript, to antagonisms that workshop culture seems to maintain.

These thoughts and remarks are genre-specific because poetry has been my area and this occasion is "Poetry at Bennington"; feel free to substitute prose or another art form where you can.

I feel I've been leaping. Lemme back up.

My name is Justin Phillip Reed. If I am known to you, it is presumably as the author of a collection of poems that has received awards or acclaim from agencies of some prestige, and/or as the recipient of fellowships from prestigious institutions, and/or as the student of renowned professors at prestigious writing schools. *Prestige* is a word that used to refer to conjure or illusion.

I have lately found myself facing a screen of illusions about what I create, to whom I relate, and how I encounter the sound of my name. I think I know how I arrived here, at crisis, at alienation. Mostly, I recognize the decisions through which I've tethered my life to the production of text that tends to rail against the very structures that philanthropically fund its production—a text, therefore, that refers only to itself.

Why I have allowed—why I've seemed to *welcome* this, has been less comprehensive to me; so I take refuge in horror films, which is where this presentation really wants to go.

I hope this is the final lecture of my alienation. It is titled "Leisure, Labor, Reticence, Violence": originally a coming-to-terms for the dialogic contradictions I've come to see as characterizing the desperate protagonists of horror cinema. The problem unfolding from what was at first a harmless curiosity about a generic narrative formula is that, under continued, often haphazard scrutiny, and through the trials of self-awareness that knowing where the hell I live involves, horror cinematic protagonism looks a lot like my writing life, which I've been calling, simply, "my life." Maybe you recognize the script:

I am a (laborer of _____ kind) at (institution that disrupts my living by leeching output in service of its highest stockowners), working under the threats of hunger, illness, and dispossession

is not unlike

I am a protagonist of a film in the _____ horror subgenre; I am running or fight-ing under the threats of mutilation, death, possession, or madness.

I could be overstating horror's generic intelligence, though I don't believe I am. People tend to automatically underestimate horror films, generally dismissing them as desensitizing fodder among new visual technologies, while they are in fact as referential, allegorical, archetypal, punctuating, and self-conscious as the poems that first incited me to write poems with any devotion. Horror is a site where I expose myself to myself; it keeps the odor of my animal panic sharp. Another of these sites, of the illegitimate "'body' genres," Clover tells us, is pornography.[1] Horror and porn are deeply interested in "what it means to be human," as poets claim to be.

I think that poetry, when I've most lusted after it,—and I want to recover that lust—is a body genre. Chills, sweat, nausea, horripilation, palpita-tion, salivation, gritted teeth, clenched sphincter, breathlessness, restless legs, etc.: I consider a good poem one that affects me physically. A few of them *in*fect me, such that I find them / feel them living in me, at times without invitation, and not for the purpose of my reciting them but for their own purpose: to revise me.

Dawn Lundy Martin's *DISCIPLINE* is made of such poems. Repulsive, wheezing poems that smell of illness, things grimy with self-satisfaction or social performance, humiliatingly horny. I bring up this book a lot, like vomit. I am still full of *DISCIPLINE*, still somewhat possessed by it; it goes everywhere I do, and gets packed first when I discard two-thirds of my poetry library and disappear from the city.

1. Clover, "Her Body, Himself: Gender in the Slasher Film," *Representations*, No. 20, Special Issue: Misogyny, Misandry, and Misanthropy (Autumn, 1987), p. 188–189.

I suspect Robert Hayden's "The Diver" of a similar business in my body. Whatever part of me also desires to "have / done with self and / every dinning / vain complexity" desires drowning, some sort of dying, and desires it constantly, swims ambivalently around the shell of that dead ship. My body knows that it preceded me, and that it will succeed me, and it remembers something of being unnameable again.

Crisis, in a sense, refers to a decisive point in the progress of a disease. If I should say a poem functions "critically," I probably mean that it holds skin-splitting as an aspiration, foremost, that it means to leave a mess that is an opportunity to better know what I'm made of. I am *self*, "vain complexity," a reticent survival response to cohabitation anxiety and social stimuli. I look for poems to be rug-rufflers, to creep under that ivy of self.

Similarly to horror cinema, poetry risks and, at the same time, relishes in circularly retreading and canonizing its own conventions. In the pursuit of a legitimate genre, or the pursuit of a generic legitimacy, I became attracted to poems about poetry, poetry accountable only to poets, poems that act like poems and could be read and published where poems are read and published—attracted to receiving the recognitions that recognized poets receive and bestow. This happens when, for instance, we consecrate art school, or we find it necessary to uphold the circumstances under which a life lived deeply in art is impossible without subjecting that life to a stratified, professionalized, board-certified, peer-reviewed living.

I'm lecturing now. I'm trying to remember why it matters that the speaker of Whitman's "When I Heard the Learn'd Astronomer" ultimately rejects the lecture hall for a naked-eye education but does so in perfect iambic pentameter. I have a bad habit of iambic last lines. Many of my poems are etudes, if not most.

Having as its rawest material basic, fleshly vulnerability is horror's distinction. People keep inventing and iterating ways a person can be hurt and afraid and enraged and relieved like we keep morticians in business. At the end of the day, we show up for the body.

What is poetry's body?

Like manhood, *poetry* itself hazards a melancholic ideal, a referent we keep trying to represent. Its reputation for internal investigation has law-enforcement energy. Professional poets like to distinguish poems using concepts such as style, voice, syntax, structure, image, line—concepts that are often local and relative—or is that not why we name-drop in workshop? These are arguably recognizable *as* craft elements according to access and behaviors summarily called "taste," all of which have to be aggressively regimented lest we lose sight of the lyrical practices favored by some people who sought to successfully endear themselves to aristocracy and, by patronage, escape the ravages of manual labor, forced migration, disease, and death that follow the loss of birth lotteries. Oh, wait.

What is a person to a poem if a poem's appeal is that it need have nothing to do with people? Am I still studying, teaching, and writing poetry according to isolationist values intended to amplify the blisses of a mind at ruling-class leisure, values intended to obscure the coterminous or enmeshed circumstances of people who are massively deprived and made servile? So maybe I'm just being a brat, and maybe throwing my blood into this ecclesiastical endeavor that edifies itself with "selectivity," "competition," "genius," and other names for omission, but meanwhile encloses a vacuum of actualization, is one very white thing that I've done. And my mother has been so proud.

Who is poetry's people?

•

I have this anxiety of writing or being a monument to ways that I do not live. And I have some idea why the obelisk audiences have made of Ari Aster's *Hereditary* annoys me.

The film's first act asks intriguing questions about people, about how we frame a person, about the models people impose upon relationships, and

whether we are bound to fail those renderings. Mourning is the lightning illumination of these failures, as is true in the family dramas like *Ordinary People* and *In the Bedroom* that partly inspired *Hereditary*.[2] Family is commonly a knot of flesh vulnerability, of horror. *Hereditary*'s Annie Graham is a fucked-up mother, or she is just a mother. Annie's dead mother did what she believed was best for her family, and thereby cursed them all. The conflict between expectation and chance, or between order and chaos, is the force that problematizes everyone.

Annie's daughter Charlie, nursed as an infant by Annie's mother, centralizes this problem. Annie composes detailed miniature representations of critical scenes in her life, using artworks fated for public consumption to intervene in a bizarre autobiography. Charlie—who sculpts crude figures out of odd discards, draws distorted portraits of people around her, infamously and inexplicably clicks her tongue, and appears to live on a diet of chocolate—defies all attempts by the family at a semblance of normality, and kind of illustrates the impotence of their (counter-) influence. (Charlie's grandmother "wanted [her] to be a boy".)

Peter, the son and brother who exists with his father Steve on the fringe of this maiden-mother-crone tripartite distortion, rounds out an atmospheric condition of cinematic reticence that I'll return to later. And it's *with* Peter, through an attachment to his subjectivity, that the film first ushers in violence.

For the time being, I dream that, at half an hour in, there's more than enough tension to tell an excellent, dread-threaded story of this family. But the occult narrative is cutting gradually into the film, and its insistence is reminiscent of those poems that early know how they want to

2. Peter Howell, "Hereditary Director Ari Aster Preys on His Own Deepest Fears," *Toronto Star*, June 7, 2018, https://www.thestar.com/entertainment/movies/2018/06/07/hereditary-director-ari-aster-preys-on-his-own-deepest-fears.html. *Ordinary People*, directed by Robert Redford (1980; Paramount Pictures). *In the Bedroom*, directed by Todd Field (2001; Miramax).

end and intend to be written in that general direction. *Hereditary*'s own self-consciousness acts as a provocative secondary tension, and it has to struggle under this narrative structural anxiety, which calls out to but leans away from Pasolini's meaning when, in *Heretical Empiricism*, he described an autonomous "contamination" in which the camera's detailed digressions compromise the character's narrative excursions:

> a deviation from the system of the film: *it is the temptation to make another film.* In short, it is the presence of the author who, through an abnormal freedom, transcends his film and continually threatens to abandon it, detoured by a sudden inspiration—an inspiration of latent love for the poetic world of his own vital experiences.[3]

This *other* film is an abandonment, but one without transcendence. While Charlie's death at the close of the first act is its expositional past, this new film begins earnestly in the second act, when Annie commits to experimenting in spiritualism and the narrative commits to a formula; it starts to look a lot like other influential horror films but it isn't deeply any of them. Expectation overtakes chance. Aster seems to decide that the way out of his film—which is at times a flaying experience in its forbidden honesty—is involution, is a totally conceited (i.e., metaphorical) ending. Therein the film itself seems to decide it is indeed a scary movie. It ceases to be curious about its characters, since they are no longer characters who are vulnerable to each other but are instead models that are vulnerable to the text's exploitations for a predetermined effect.

Before *Hereditary* succumbs to its monologue, and maybe as a way of resisting monologue, the film appears to argue with itself. It cannot settle into one perspective sympathy nor one subjectivity. It employs echoing shots that function similarly to pararhyme, revisiting and revising material to show it as malleable, in turn exposing various facets of characters.

3. Quoted by Naomi Greene, "Theory: Toward a Poetics of Cinema," in *Pier Paolo Pasolini: Cinema as Heresy* (Princeton: Princeton University Press, 1990), p. 119.

I'm attracted to this camera's discontent, its disorientation. It drops out of an omniscience whose lexicon is omens—one that tells me to pay attention to Annie's hand slicing cherry tomatoes for dinner and then later to the partygoer's hand gripping an identical knife to vigorously chop the walnuts that will trigger Charlie's anaphylaxis.

It drops into a real-time free indirect discourse that, in one shot, assumes Charlie's point of view as the light post, filling the frame, speeds toward her face; and then, within this same sequence, it fastens itself to Peter's point of view as his eyes struggle to enter the rearview mirror reflecting his sister's decapitated body in the backseat.

This camera holds Peter's face as recognition overtakes it. The camera's stillness leaves his trembling irises comparatively frenetic. I am discouraged from looking away from his inability to look at.

This deepening expression, which is an effect of the film continually questioning its shape (in my mind I've been calling its extremity "formal violence"), conducts a viewing experience in which Charlie's death scene is paroxysmic and agitating. An infection.

If this camera were a "lyric I," we would torture it in class. We would bind and amputate it and pluck its eyes out. It's doing too much. It's dialogic and then it's detached. It needs to make some decisions.

Hereditary's first-act mimesis—this indecisive, neurotic camera—forms a state of relatable insecurity in which compassion for each character becomes possible. For that reason, I find it almost unforgivable that

the film concludes not in this vagrant wisdom but motivated instead by attesting its knowledge of device, paying predictable and on-the-nose homage, treating each of the characters with a new cynicism as they are revealed to be tools in a cult ritual to summon a demon. Now that Toni Collette's portrayal of Annie invariably entails hysterics, now that rigid skepticism and distrust exclusively characterize Steve, and now that none of them has any effect on the outcome, the camera too seems to surrender its previous autonomy. I don't mean it necessarily does anything so differently; on the contrary it does what is expected and does not reckon with its employment in this different film. It stops questioning the shape.

Annie's trashing her studio and destroying her miniatures at 1hr 23min seems to complete the transition into the final act, the abandonment of the first film. Is it a significant metacommentary? Maybe. Annie says she "got tired of looking at it." This might be her synecdochical rejection of reticence and the expectations assailing her labor. It might be a rejection of structural anxiety on the behalf of Aster's writing and direction. It would be a rejection of convention in gesture only, which renders these other possibilities frivolous because, like Whitman's starry eyes and my iambic habit, this final act still dreams of leisure as a certificate, something you do the time and study the masters to earn. It speaks of freedom in terms of showing you what it knows.

[This leisure fantasy asks me to live in my mind like a wet spy in a high-rise petting a heavy gray cat. Scarlett Charlize. Service elevators are positioned to be easily forgettable. "Cruel optimism" sounds like silk stretched over steel in a room of wall-to-wall glass.]

•

Here, being anywhere, is a snare of labor. As I write this at 10am, three brown-skinned people in baseball caps are mowing, weeding, and clearing the backyard. It isn't my yard, but I currently get the most enjoyment from it. I have time. When they finish shearing the grass and

leaf-blowing the deck, I look out at the results from the window of the room where I sleep. This yard and this hedge of woods composed my poem "Considering My Disallowance"—my disallowance being beauty and the Blackass leisure to appreciate it in this state that has the highest number of active Ku Klux Klan organizations, though here is anywhere. I have time, though I tire of time being stolen from someone else. This is not my house; I'm staying with a friend who works as a dean of the university where I decided to become a writer. He was my professor then, and a writer by passion. Now he doesn't take much time for his life away from work. He doesn't write and he can keep this house, and he can offer me a room and food and pay people to keep the greenery in check on a weekly schedule. Me, I clean the kitchen and wash the windows and harvest the garden and give the dog attention—I can, not must; I have the gift of time. But tomorrow is October, all the weeds will die soon, the hedge will be gruff and brown, and I won't be around nor will the sound of the mower. Maybe my friend will save money not housing me, not hiring people to tend the ground. He may get a different job, take a pay cut, take some time, write some thing. Three brown people in ball caps don't get paid to talk about this yard they know most intimately.

•

Clearly there's something about Rosemary.

Of course, there's something about second-wave feminism, Cold War paranoia, white entitlement to upward mobility, the myth of the nuclear family after the fifties, a Holocaust survivor's commentary on anti-Semitic paranoia, Roman Polanski being a "bastard and a criminal,"[4] and Sharon Tate being murdered by the Manson cult the year after *Rosemary's Baby*'s release while she's carrying Polanski's child.

4. Philippa Snow, "PSA: Hilary Duff Played Sharon Tate in a Straight-to-Video Manson Movie," *Garage*, Vice.com, April 30, 2019, https://garage.vice.com/en_us /article/nean7b/hilary-duff-sharon-tate-movie.

But if in this formalist appeal I may continue to pretend that the art is central, then we have this film and it has its protagonist. Rosemary wants to start a family. She gets to start a family. She also gets manipulated, drugged, raped, gaslit, confined, abused by her doctors, abandoned by her husband, and alienated from her friends. These brutal intrusions happen on the way to getting what she wants. Maybe because Americans claim to be social descendants of a Greek tradition in which leisure must be a relief—otherwise it is wanton—they tend to accept grueling labor (better if it's someone or something else's labor) as par for the course of living the life one wants. Rosemary accepts months of debilitating pain as par for the course of her pregnancy, and her husband arranges her terrible incubation of Satan's offspring for the sake of his future in Hollywood. Some people accept and impose all sorts of indignity in the pursuit of careers. Sure, Rosemary's desire is oversimplified; this makes her rather realistic.

I think we can recognize as patently untrue the predominating assertion that protracted labor is a means toward protracted leisure. Leisure can be hoarded; labor can be further alienated to support this. Horror, rarely acknowledged as a legitimate genre and therefore open and vulnerable to delegitimized knowledge, experiences, and propositions, plays with a plot structure in which leisure importantly is cast as a state to be reclaimed or revisited, and the means toward it as transformative violence. Labor in common horror—when it's most frequently encompassed by bare survival—is disruptive.

There's evil about Rosemary, and it's making hard work for her. Initially she copes with it by asking about it, and then by shutting up about it. It's in her head. It's in Chris's head in *Get Out*.[5] Seems it took forty years for everyone to believe Laurie Strode in the *Halloween* films.

"There's no one there." "You need to relax." "Get over it." This is the atmosphere of reticence holding its ground. The protagonist's going-

5. *Get Out*, directed by Jordan Peele (2017; Universal Pictures).

along, complying with this assertion (of form) when something doesn't feel right, deepens alienation. Their labor intensifies as the rules for what can happen to a person appear to change while the ways a person can respond do not. Watching the movies, we readily call bullshit at this juncture.

Does academized and industrialized poetry *feel right*?

Who can afford professionalization? Who has the time?
What have I done to endure academic-industrial environments?
What am I doing to help them endure?
What are the men discussing so discreetly in the smoking room?
Whose occupational ambitions take precedence?
How does professional pedigree legitimize writing?
Why does the dessert have a chalky under-taste?
Whose labor do we understate and underpay to elevate the value of professionalization?
Who desires the conditions that deny the overlap of poetry and manual workers?
Why does my poem ignore people working?
Why is he taking her clothes off?
Who governs legibility and interpretation? Who supervises sense?
What do you mean, *success*?
Is this a dream come true? Is it a dream? Is it really happening?

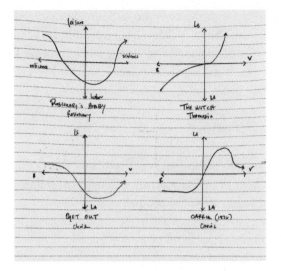

I ought to have made this digression earlier: For *reticence*, my most ideal referent may be the state of which Carrie White is earliest exemplary in Brian De Palma's *Carrie* (1976): she's wholly hushed, self-restrained, closed, not yet coiled; minimally reactive to sense stimuli in a way that stops short of Michael Myers's catatonia in *Halloween* (1978) but includes the hesitation, reluctance, doubt, trepidatious moral boundedness, and passivity that characterize the (especially psychologically wounded) protagonists and franchised survivors of horror films.

But I mean for *reticence* to also imply, less literally, the total text's affective signification of reservation; a mandate of keeping-it-together focused in the protagonists and shared by the narrative pacing, dialogue, length and variety of shots, the predomination of understatement as opposed to severe stylistic awareness, etc.

Similarly, I mean by *violence* not only the nature of conduct between characters but also the relative high degree of acute feeling expressed in the cinema—by characters, camera angles, rapidity of cuts, intensity of score, and the atmosphere affected between them; violence as the anticipation, eruption, chaos, and residual stain of the chthonic (anti)social id; acute feeling expressed unto the distortion or destruction of the film's established norms.

These norms can be distorted or destroyed in people—transformative violence. The transformation is important to me, I'm a sucker for it. Wild-eyed, knife-wielding Rosemary is not timid and nodding when she claims her authority over the truth. Chris gets free of his captors, ironically, when his face breaks into one barely recognizable, contorted by ruthless, ecstatic brutality. In *The Witch*, Thomasin questions the form— the farm, the family, the faith—and once each of them is ruined she ascends in the violence of jubilation.[6] Was she a witch? or was "witch" simply the only known name for a woman at her leisure? Before she gives

6. *The Witch*, directed by Robert Eggers (2015; A24).

her name to Black Phillip's book, she goes to sleep like she hasn't slept in a long time.

In my experience of films, violence likes to "rise up" through dreams or nightmares. If the camera of "the real" walks, the dream camera dances on ceilings. Though, of course, things don't rise up in most dreams; they just suddenly are, and have been. Hélène Cixous says this:

> In the text, as in dreams, there is no entrance. I offer this as a test to all apprentice-writers: if you are marking time you are not yet there. In the text, as in the dream, you're right there. Moreover, this is why texts can create resistance in a certain number of readers. Many readers cannot stand to have the stranger right here. If you haven't, as a reader, burned your house down, if you are still at home, then you don't want to go abroad. People who don't like what I call "the text" are phobic, they are people who, in other situations, dislike being displaced.[7]

Which are these other situations where people like being displaced? I think it is European to be romantic about losing one's home. But I also think that this resistance to the text, as compared to the dream, could be useful to consider—useful, again, not in the creation of poems but for the possibility of abandoning the thetic tyranny of poetry.[8]

Cixous goes on to offer, "*It is the feeling of secret* we become acquainted with when we dream." I know the feeling. When the act of writing a poem is dreamy it keeps me up late—I follow it in blind faith because it knows something I want to. The famous Salvador Dalí-conceived dream in Alfred Hitchcock's *Spellbound* is a synthesis of two secrets that are crucial to the outcome of multiple characters' lives. The violence that enters through this dream culminates a half hour later in this shot: a

7. Cixous, "The School of Dreams," *Three Steps on the Ladder of Writing* (New York: Columbia University Press, 1993), p. 81.
8. As for transcendence (via Pasolini previously), I don't know that I trust any pursuit of it having to do with poetry that can be awarded.

revolver in the camera-viewer's hand, first targeting the protagonist and then turned and aimed at us, ultimately fired. I did want to *know*, after all. This, the exploitation of our desire for the camera's unbounded eye, which has no secrets, is in December 1945: the Second World War has crested, the United States has destroyed hundreds of thousands of people in the atomic bombings of Hiroshima and Nagasaki, and guilt is everyone's complex.

In *The Innocents* (1961), the governess Miss Giddens wants to "learn what it is these horrors want," the horrors being the spirits she suspects of possessing the children she cares for.[9] Her dream is an unprecedented compression of disjointed dissolves, close-ups, three and four action shots overlaid in one, children's whispers of "it's a secret," her own disembodied voice saying in a recent memory "you are in supreme authority," though in this condition she isn't.

None of these dreams is a monologue. Rosemary's dream is a fish on the hook of Minnie Castevet's overheard voice, hanging from the mouth of a nun. And when Rosemary herself speaks into the dream, it is in confession of a secret.

I am thinking that if I'm going to love writing again, if I'm going to one day newly hear my name, if I want a text that aspires to life as much as reflects it, I'm going to have to dream. And I'm going to have to pull violence, like a Krueger hat, out of dream. I am thinking that poetry composed in and of the conditions of reticence—poetry bent to prescription, homogeneity, and self-absorption in its construction—needs to submit to the indiscrete domination of dream, its promiscuous scenes, its insecure subjectivities, its cacophony; needs something like indecorousness and the guttural expressions of horror—the "humanity" of horror.

If I am a poet, I am not a poet of local royal court or closed-door avant-garde experiment, but a poet of modern empire: of a global labor class,

9. *The Innocents*, directed by Jack Clayton (1961; 20th Century Fox).

extinction events, space-transport weaponry, hypersurveillance, anti-critical culture, and a pocket device that advertises relentlessly. My poems will have to be accountable not to poets but to bodies—how I lived in mine among you in yours, constantly vulnerable to input, assailed by social control, perceptive distortion, heightened adrenaline, illness, difficult cohabitation, and temporarily separated but inseparable from people writing poems in prisons.

But poetry concerns me less than does the possibility that institutionalized creativity is a labor formation that forestalls the potential of a very necessary social transformation in this country. Bored, bureaucratic, self-centered artists are unlikely to imagine and rehearse different realities. A final girl who can't craft the destruction of her killer can only keep running and hiding. And right now I'm just on the run.

LEIGH WHANNELL'S *THE INVISIBLE MAN* (2020), OR THIS SONG IS TOO ABOUT YOU

Clopping down hardwood hallways with ridiculous clown steps symptomizes white people's wispy attention to the matter of their bodies in space. Their bones develop disbelieving in police boredom, belts, backhands, in-school suspensions, eyes of the ilk of assistant principals haven't felt them up enough.

Surveillance surprises Cecilia as, the film insists, it should me. I, who this horror is not for, untoward, should not have been born on guard for the extremities of regard, born strangling at the edge of my mother, who named me for a tiptoe in the door, a birth-certified hire with a nice ring to it, rolls right off of clean teeth: "Justin Phillip Reed" expects a frame to fill itself

as the camera does. A camera Venn-diagrams vicarity & vanity. My friends are binging *Big Brother* in their living room. The drapes are drawn. My drunk friend tells me we call capitalism the wrong name—all of Marx's epochs, even, citing Orwell's *Homage*. People ode on Orwell for dramatizing mass gaslighting like he & Du Bois's *Souls of Black Folk* weren't the same age. Lowercase slaves play bagpipes in the margins of this page. You like to act brand new to being unmade in my image, or

this novel paranoia of occupation is the juvenilia of native imperial citizens. Cecilia is distraught to find herself unsafe everywhere, but everyone knows what happens in the Black girl's bedroom; the camera bets on it. In Wells's fiction, the explicit dream of white invisibility is impunity: to dwell in the shadow of a doubt in the light of day. From Yule lads being lads to Kevin Bacon rape, only the bullets that miss are suspicious. In the book, Griffin says he went to work "like a nigger."[1]

1. *Like* is like *nigger*, a greasy finger-fondled reflection, a signifier sent out to obliterate singularity & solve for service the problem of semantic resistance. *Niggerlike* an optical technology, a thousand-camera suit, a humid shimmer of image bent n-word. Cecilia's baby daddy a glassmaker, his "guilty snigger heard running round the room (Rae Armantrout)."

My lover's still a country convincing me I can never leave. He makes me feel like I'm the crazy one. He controls, & I quote, how I look, what I wear, what I eat, what time I leave the house, what I say & think. My lover is the mall in Johnson City, Tennessee. I have no country but a commercial district. Hurt & submission & clearance for dessert. In the movie where I cut his throat to save my life, they make me

Elizabeth Moss, secretary & receptacle of subtotalitarian emotion, a symbol of inequitable diminishment to hysterics, historically; in this form I'm forgiven getting free by any means, & I get to walk away. Little black dress dropped into little black night & a big Black cop for an alibi. The salt-stung wind whinges, the waves parade. I have turned the proverbial table. Spidery piano score escorts my denouement. Elements collect in applause & collude to conceal me in mystery ideally no longer required. I sure did let him fuck around & find out on the floor of his Teslacrat mansion

no person appears to scrub, mop, dust, or polish. Honestly, *suspense* is the misnomer. I already told you: I know where I am. I'm not allowed to forget the state we're in

where my baby sister resembles Storm Reid, particularly around the nose that no one we can see has tried to knock off her face. In my panning anxiety a filament whistles at high frequency incessantly. It is summoning Assata with bravado. It is hunting Sally Hemmings & holding Billie Holiday for observation. It is easy to say "the camera" as though it still drags me along.

THE BLACK GIRL BEST FRIENDS AT
THE SURVIVORS PARTY

EXT. YOUR BASIC-ASS SUBURBAN SLASHER HOUSE—NIGHT

KARLA (Brandy), DONNA (Nia Long), & HALLIE (Elise Neal) approach
the house. There's a party inside. KARLA pauses in the middle of the
walkway, the other two behind her. Three white girls crash through
upper-story windows simultaneously & hit the ground in ceremonious
showers of glass; two of them are Sarah Michelle Gellar.

> HALLIE
> (to Karla)
> Move your ass, okay? You're late.

> DONNA
> Late? You're always late. There's nothin new.

Loretta Devine walks out the front door with a plate of finger foods in
one hand & a gun in the other, waving at them with her pinky as she
passes, chewing.

> KARLA
> You know what, I have an idea: why don't we all—

> DONNA
> (stomps out her cigarette & kicks the butt into the
> grass)
> I'm right here with you.

INT. HOUSE PARTY

The three stand together in the foyer, staring into the party. The music
is Garbage. Tony Todd dances with himself in a hallway mirror, hum-
ming "Return of the Mack." In the living room, Virginia Madsen stages

La Pieta in a recliner, her tears wetting the cheekbones of Linda Blair. Patricia Arquette stands behind them holding a wrinkled sheet of paper; between poses the three workshop her acceptance speech / a White Women's Bill of Rights.

> DONNA
>
> Somebody needs to tell me what's going on.

> KARLA
>
> What the hell would you call this?

> HALLIE
>
> It's a party. Free beer? Meet the girls?

They look up. On the ceiling, scrawled in burnt sage ash:
KASI LEMMONS / THIS.

> KARLA
>
> Aint nothin free in this world. Everybody says it, & it's true.

> DONNA
>
> I don't understand.

> HALLIE
>
> It's a sorority.

> DONNA
>
> I don't understand why there's so much blood.

Somebody's phone bleats the audio of Jennifer Love Hewitt yelling "what are you waiting for, huh?" on loop; it's an alarm. Jennifer Love Hewitt pulls a crabmeat meatloaf outta the oven, drowns it in cocktail sauce, & sticks a birthday candle in it. Rebecca Gayheart approaches the crab cake with a blowtorch & a can of hairspray.

KARLA

We gotta get the fuck outta here.

DONNA
(somehow smoking a J already)
Do you smell flowers in here or something? It smells like jasmine or hyacinth or something.

KARLA

What'd I say?

HALLIE

"Stupid people go back, okay? Smart people run. We're smart people, so we should just get the fuck outta here."

DONNA

It's Friday night. I think you're taking things a little too seriously. Where you goin?

KARLA
(backing toward the door)
I don't wanna be the one to say I told you so.

HALLIE
(waving brightly at random final girls)
I just think, despite its trivialities, it is a life-affirming, mentally stable, healthy environment for you—

DONNA

You're so dramatic.

HALLIE

I'm her therapist. I mean, look at this freakin place.

Neve Campbell descends the stairs with a potted cactus in each arm; slung over her shoulders & crisscrossing her back are an assault rifle & an umbrella. She walks into the thick of the party, where the flaming crab cake is being presented to an excited Jamie Lee Curtis, who's still having her face applied by Heather Langenkamp.

> KARLA
>
> The fuck are you talkin about? Man, this classifies as a fuckin emergency.

> DONNA
>
> I'm gonna take you home now, okay? You are gonna drive yourself crazy.

> KARLA
>
> Nobody thinks you're crazy.

> HALLIE
>
> It's okay to break. Just lower the walls for the next few days, okay? This self-induced isolation you got going? It's not healthy.

> KARLA
>
> Oh, girl. You don't have to worry about me. I'm made of steel.

KARLA keeps backpedaling until she walks completely through the storm door à la Michael Myers in *Halloween II.* More glass.

> DONNA
>
> (momentarily resembling the Nia Long of *Soul Food:*
> one cocked eyebrow & also a hairdresser)
> You look like shit. You've got stuff all in your hair. I just wanna get you home.

> KARLA
>
> I *am* holding your hand.

BUFFERING AT 31% WHEN KIRA & WILL HAVE JUST CLASPED HANDS IN THE FINAL SCENE OF *THE INVITATION*

My man puts me in situations. Agreeing that he is my man was such a situation. Once upon a time, touchin buckles at the honky-tonk bar was too far. That was before some good ol boy on a banister leaned in my man's ear & encouraged him to kiss me. I'm grown now; I can invoice my choices. I did beg for the throatfuck in his blue pickup on the road to the airport, but it's been a long minute since my listenable intuition was in me. Everyone has somethin to say about what they would do were they in this situation; they'd be hungry. My man takes me to his rich friends' dinner where I'm still sipping wine when John Carroll Lynch enters, resembling the dictionary-definitive figure of a killer. The cheddar is sweating on the table. I've become too accustomed to their chalk snacks, small talk, tracking stock, hand-wringing about republicans, getting tenure. I've been ambling from error to error in agreeable weather, unable to sniff the illness in grapes, the disarming measure of honey in cake. We really oughta pull the car around, but I put up & shut up & let these gays insinuate that I'm a baby incubator. My man can out himself as a hater; he's the one dating a diversity hire. He could also stay in LA & holler over the alarms that it's harmless. He's the kind of child they need to keep breathing. The heart of his beauty is he wavers like wheat & feels widespread. His constant calling our surroundings "problematic" means to persuade me that we simply sojourn here & aren't interned. Tell me what possessed me to bury my shotgun & ride ammunitionless on my obituaries into civil bewilderment & hear these people out when they claim their pain is optional. My man has more problems than money & I worry bout his mercy for dying coyotes. Back when I believed in omens, I would've left when I got good & ready. Instead I steady myself with a grip on expensive woodgrains. My man steps over the corpse on the stairs. I & my tall, handsome bad habit, we watch the fire sliding down the hills: the sum of each screaming red flag. I am often sad to love this man. Some times I'm here for the thrill.

"Now, I am, personally . . . and publicly . . . so traumatized by
the bourgeoisie that my hatred against it is pathological by now.
I can expect nothing from it, neither as a totality, nor as creator of
antibodies against itself (as happens in entropies: the antibodies
growing up in the American entropy exist, and have a reason to,
only because there are negroes in America . . .)"
> —Pier Paolo Pasolini, "Apology (for 'The PCI to
> Young People')"

"After all we've endured, after what we have seen—what men
can do—you think it is bumps in the night that frighten me?
You think I can be afraid of ghosts?"
> —Rial (Wunmi Mosaku), *His House*

When I worry that the anesthetics of NFL broadcasts, Pittsburgh piss
beer, and endless, reiterative film franchises have begun to erode my
mind down to an inert stone, I resort to smoking and insulting the eve-
ning sky with a clichéd manner of study I think is endemic to writers.
Six-o-clock iridescence disintegrates to a blue-gray gradient, the way what
I've grown full of lacks the grace to be called *desire*. I'm horny as fuck, and
no socialist revolutionary's philosophy is coming to rescue me from the
doom of being hot for my landlord.

He's kneeling on the bathroom floor, replacing two burst pipes and stuff-
ing a roll of cotton-candy fiberglass insulation into the wall through a
hole so small and low to the floor that, when I say I'm watching him to
wield this experience against a future winter's subzero dip, he reminds
me that all I can see is his ass.

Have you seen Antti Jokinen's *The Resident*? Say you're invited to view
a New York apartment where the natural light is so rife the sun might
warm the hardwood, and you find Jeffrey Dean Morgan in painter's
pants, running a belt sander, sawdust in his salt-pepper. You learn he's the

landlord and you can afford the rent. What do you do? I mean, who can blame Hilary Swank's Juliet for how sideways this goes. Being hostage to the housing market is hard enough without passing up the chance to smash the on-site bachelor who helped haul in the mattress.

The consequences are of course disastrous, but so is this narrative. And what hope is there for it once it clearly designates Aunjanue Ellis's Sydney as existing solely to boost Juliet's bruised, white ego—to tell her she's enough, her ex is an asshole, let's go out and get that groove back? This wasn't the only role in 2011 that cast Ellis as the help, but the Black-friend-as-auxiliary-emotional-power archetype was already trite in the nineties. When eleven years later we encounter Mollie (JoJo T. Gibbs) in *Fresh*, the trope is anything but. To be close to another person and not recognize what endangers them seems unnatural—unless you are yourself the danger.

I suspect that my neighbor kinda despises me. Maybe he's right to.

There's a tightness now in my lower back that I had tamed two years ago with martial arts and a massive dictionary, roly-polies on a violet carpet. Whenever I'd start to talk too much, my army dom strolled in the door to find hot coffee and ice water and—upstairs waiting nearly naked save the jockstrap he mandated along with phallic chastity—a good boy kneeling and facing away from his entry before he'd overthrow the absence in my throat. I was always home and covered in coconut oil and health insurance courtesy of the university I easily avoided, spending the minutes fingering bass and attempting to figure what Pasolini's "hypnotic monstrum" could mean.

I can't play that way on this block. I live not in an isolated, lofted carriage house obscured behind a large building but in the third-floor apartment of a former family house, accessible by a door that won't shut unless you fucking slam it (which is unsurprisingly not a priority to my hot landlord). My visitors have to park on a crowded one-way ending in an elementary school and stand on a porch that is visible from at least fifty-two windows, six of which presumably belong to that grumbly MF who

smokes up outside all summer in the company of good oldies and never waves back.

It's cool. I'm too tired to host as many redheads as I indiscreetly did when I first moved in. Since I began landscaping full time, I'd rather slump in my own funk of musk, mulch, cigarettes, and gasoline, my aureole of residual road salt, rust, mud, and pulverized concrete, than clean everything in the vicinity of a twenty-minute quickie. But my neighbor can still, figuratively, eat my ass.

I'm not indulging this diaristic impulse with the intent to exterminate any silly mystery that tends to coagulate around the vulgar existence of poets who say a lot of nothing in interviews and then fall off. My defunct dream of a golden coexistence warrants some reflection while there's earth under my fingernails, and I think min(d)ing my immundity/mundanity is learning me a lot about company and crowds.[1]

I'll be thirty-four this year. If I haven't figured out by now how to stopper my soft sociopathy, I doubt I will do. I get that I've swallowed the spit of too many white dudes to peddle a respectable opinion on "the culture," and having therefore lost the race war for my soul quite outright, I have nothing left of the compulsion to pander to y'all from inside the romance of Black participation.

I don't know which occurred first in 2020: I stopped praying to my dead relatives, and my labradorite stone necklace snapped and left me to my mess in the summer grasses of Schenley Park. But since then the devil

1. That the "earth" under my fingernails is mostly mushroom manure, and that I daily taste dirt between my teeth, surfaces Cixous's discussion, in "The School of Roots," of Clarice Lispector's *The Passion According to G. H.* Lispector writes: "Because I did not want to become imund like the cockroach. What ideal held me from the sensing of an idea? Why should I not make myself imund? Exactly as I was revealing my whole self, what was I afraid of?" Cixous insists upon translating Brazilian *imundo* (French *l'immonde*) not as English *unclean* but something closer to *out of the world.* See Hélène Cixous, "The School of Roots," *Three Steps on the Ladder of Writing* (New York: Columbia University Press, 1993), p. 116–117.

has indeed worn me to prom in Pittsburgh; and somewhere between the fluids I've exchanged and the shifty romance of the river confluence and all the George Romero worship, I've firmly figured that, if Romero truly cast Duane Jones to play the lead in *Night of the Living Dead* because Jones was "the best actor to show up that day," and not at all because he was Black, people oughta be ashamed to repeat that shit with big grins the way they do.

In the third-season finale of *Atlanta*, Stefani Robinson and Donald Glover got post-cancellation Liam Neeson to say, "The best and worst part about being white is we don't have to learn anything if we don't want to."

From the depths of my blue-collar catheter bullshit, I'm here to remind you: Inclusion is almost always reckless as hell.

I mean, that wig Danai Gurira had to don in *The Walking Dead* is one thing.

But then Michonne devolves from spectacularly fearsome, katana-wielding warrior to Rick's kids' babysitter / governess / wet nurse / don't make me say it.

T'Nia Miller as the lonely, gorgeous, amnesiac ghost of the governess Mrs. Grose in *The Haunting of Bly Manor,* plagued by headaches because her skull cracked across the bottom of the dry well.

All I want for season four of *You* is all I wanted in season three: Joe's hands off Marienne (Tati Gabrielle) because her being a recovering addict trying to retain custody of the daughter she had with an abusive, actively drug-abusing, gymspiration-spouting megalomaniac white news anchor was amply trifling without setting Joe's equally homicidal wife after Marienne somewhere between her court appearances and her job at the library. And now Joe's fled to France to stalk and encage her.

Right now my television's paused in the middle of *Lovecraft Country*'s second episode. A snake is springing from Atticus's unbuttoned jeans into

Leti's face after she's said to him "wait" and "no" and "stop," and now her eyelids are retreating from fangs. All of the sex they have in this season will be at least somewhat traumatic for her, and they'll have to fuck a few times until she's pregnant because this is HBO after *Insecure.*

Also, that isn't Atticus. He's in the other room, getting his ass kicked by a hallucination in the form of his Korean ex-lover. Leti's being assaulted by a figment.

This is—correct me if I'm wrong—a day after they'd been high-speed chased, fired upon, and nearly lynched by firefighters and cops before narrowly escaping a pack of nocturnal, flesh-tearing mutants, the guard dogs of their current captors. It's all good fun.

Who needs this shit?

I mean, who asks for *Don't Let Go?* David Oyelowo, Brian Tyree Henry, Shinelle Azoroh, and Storm Reid are the Radcliff family; their names are "Jack," "Garret," "Susan," and "Ashley"—is this fuckin *Family Matters?* Who wants to see a shotgun blast wound howl out of Ashley's back? Who needs a Black teenager to be thrice violently murdered to heighten stakes in a time loop movie? Her uncle cop is a surrogate parent cause her father's already a heroin addict?

Black peril is a problem commodity.

People who kinda flourish historical irreverence rushed to meet and bungle nebulous demands for outward-facing "diversity" in a surge of marketable content for a genre of visual narrative that takes *bad things can happen to anyone here* as its fundamental rule. They conscripted people to whom bad things already do happen, in accordance with national canon, to decorate a practical discourse about violence that is predetermined (paid for) in its popular dramatizations by people who are purposely unfamiliar and have/love to fantasize. You'll clap when they depict Tulsa burning again.

If it were ever possible to deny that one aspect of the classic slasher's sell was its sensational disruption of the state's ruling over which groups are vulnerable to premature death,[2] we can probably thank the last decade's A24-driven "elevated horror" era for exhaustively raking the massive attraction of doomed white luxury to its root. This content's consumption implies that audiences retain at least a lukewarm awareness of some centuries of racial-capital relations signified by the mere presence of a character in a setting; which further implies, embarrassingly, that Black presence can be / continues to be consciously advantageous for its shadow of chronicled carnage. ("Readable as Black in the first place," if we recall.) Let's say "therefore" that any author of horror cinema who wants to do wrong *right* and achieve tiers of terror atop years of intravenous and total-ized terror need only cast a harassed Black.

I think this is part of what Pasolini gets at in the words above. "There are negroes in America," and therefore the narrative of American class remains in motion, roped to its beginning and its eventual, inevitable transition. The Black person merely appears, and the flesh tells (a story of capital, of human chattel, of perpetual revolt), and the story goes.

The Black person appears within the American horror cinema image system and is tasked with the absurd double duty of historicizing float-ing text and absolving that text of history by being Black there at all, all while upping the ante of dramatic brutality because, again, we shall over-overcome.

The Black person appears at the bus stop, behind the Chipotle counter, in the movie theater, up the road picking up their preschooler, and I reflex-ively pray they know safety and loving surroundings—even though, as I

2. Because Ruth Wilson Gilmore's sentence resounds and remains worth repeating: "Racism, specifically, is the state-sanctioned or extralegal production and exploita-tion of group-differentiated vulnerability to premature death." *Golden Gulag: Prisons, Surplus, Crisis, and Opposition in Globalizing California* (Berkeley: University of California Press, 2007) p. 28.

said, I don't know to what, if not my dead, I send that prayer up. That person is real to me; gods are questionable.

If it were as easy as dropping Black people into roles with colorblind idiocy, my friends and I might have lasted longer than three weeks at that inaugural writing residency in [location redacted] before [events redacted due to conditions of nondisparagement agreement].

If it were as easy as dropping Black people into roles with colorblind idiocy, your nonprofit might still have an executive director "of color."

In October 2019 I presented the essay "Killing Like They Do in the Movies" during a college class visit in Las Vegas, and one of the students, clearly aggravated, asked me afterward how I'd prefer to see Black people suffer or die in horror movies. You know, since I seem to have such a problem with it.

As someone who takes years to articulate a single preoccupation or thesis, I hate the fabricated immediacy of Q&As, and I really botched this response. I remember offering some predictable flail about simply attempting to introduce an inquiry. Fuck that dude.

But the question is, I've begun to think, right but imprecise. I mean I'm unsure that Black *people* are generally in horror. In the same way I'm unsure that my neighbor isn't just supposed to be unable to stand the sight of me because we are real opposite MFS and I do sleaze and like to bike in booty huggers, and our proximity is not a poetic delusion of community. He's real. He knows where he lives. White people and people with money mostly don't, I've noticed, and they're more likely to produce the "Black horror" / horrors we encounter. I'm now workshopping this potential reply: What if horror cinema—film and television, and yeah, the thrillers too—as it exists here, as it has come to be in this country, as it has materialized alongside this country, is inherently incapable of contending with Black life as a matter of fact? What if horror cinema is not yet for Black people? Would this help to explain why the horror films that

pay obsessive attention to realizing Black lived mystery tend to the fringe and/or veer into arguable genre designation?

Am I for real? It's a ridiculous, overreaching, bloated proposition. But what exactly would you call *Nope*?

I might be an enemy of frivolity. Can't I just enjoy the movies for what they are? Gotdamn.

Four full-grown hounds stand transparent
In the corners of the white basement.

All at once they sprint they maul a small rabbit
In the middle of the air the sterile excellence

Of walls vaults. A morning star of entrails (it
Is marvelous) twinkles between their

Democratic jaws—massacre on a mobile
Floating in the gallery / a pop-up book

In which a paper petunia flakes off of
The grommet the moment you open it.

It's sadistic direction, I whine, until Erinrose
Texts *but does [Lanthimos] even wanna fuck u*

Tho. I think [Lanthimos] is more of a shame
And leave. Agree. He's bored by role-play.

His camera is a barrel aimed at character.
Colin Farrell as the nucleus of suspended dis

Belief is a struggle. A cardiothoracic surgeon
Kills his son and gets to split the stimulus

Check fewer ways. Nicole looks over
The bullshit and sleepy. The basement,

It's apparent, keeps gnawing the rabbit's magic
Bones with the bones in its invisible mouths.

"Walk" "walk" "walk," the red gestures. The point is
Pointless, wealthy, and impersonal.

INDEX OF FILMS

Coffee House Press began as a small letterpress operation in 1972 and has grown into an internationally renowned nonprofit publisher of literary fiction, essay, poetry, and other work that doesn't fit neatly into genre categories.

Coffee House is both a publisher and an arts organization. Through our *Books in Action* program and publications, we've become interdisciplinary collaborators and incubators for new work and audience experiences. Our vision for the future is one where a publisher is a catalyst and connector.

LITERATURE
is not the same thing as
PUBLISHING

FUNDER ACKNOWLEDGMENTS

Coffee House Press is an internationally renowned independent book publisher and arts nonprofit based in Minneapolis, MN; through its literary publications and *Books in Action* program, Coffee House acts as a catalyst and connector—between authors and readers, ideas and resources, creativity and community, inspiration and action.

Coffee House Press books are made possible through the generous support of grants and donations from corporations, state and federal grant programs, family foundations, and the many individuals who believe in the transformational power of literature. This activity is made possible by the voters of Minnesota through a Minnesota State Arts Board Operating Support grant, thanks to the legislative appropriation from the Arts and Cultural Heritage Fund. Coffee House also receives major operating support from the Amazon Literary Partnership, Jerome Foundation, Literary Arts Emergency Fund, McKnight Foundation, and the National Endowment for the Arts (NEA). To find out more about how NEA grants impact individuals and communities, visit www.arts.gov.

Coffee House Press receives additional support from Bookmobile; the Buckley Charitable Fund; Dorsey & Whitney LLP; the Gaea Foundation; the Matching Grant Program Fund of the Minneapolis Foundation; Mr. Pancks' Fund in memory of Graham Kimpton; the Schwab Charitable Fund; and the U.S. Bank Foundation.

THE PUBLISHER'S CIRCLE OF COFFEE HOUSE PRESS

Publisher's Circle members make significant contributions to Coffee House Press's annual giving campaign. Understanding that a strong financial base is necessary for the press to meet the challenges and opportunities that arise each year, this group plays a crucial part in the success of Coffee House's mission.

Recent Publisher's Circle members include many anonymous donors, Kathy Arnold, Patricia A. Beithon, Andrew Brantingham, Kelli & Dave Cloutier, Theodore Cornwell, Mary Ebert & Paul Stembler, Kamilah Foreman, Eva Galiber, Jocelyn Hale & Glenn Miller Charitable Fund of the Minneapolis Foundation, Roger Hale & Nor Hall, Randy Hartten & Ron Lotz, Carl & Heidi Horsch, Amy L. Hubbard & Geoffrey J. Kehoe Fund of the St. Paul & Minnesota Foundation, Kenneth & Susan Kahn, the Kenneth Koch Literary Estate, Cinda Kornblum, the Lenfestey Family Foundation, Sarah Lutman & Rob Rudolph, Carol & Aaron Mack, Gillian McCain, Mary & Malcolm McDermid, Daniel N. Smith III & Maureen Millea Smith, Robin Chemers Neustein, Vance Opperman, Alan Polsky, Robin Preble, Steve Smith, Paul Thissen, Grant Wood, and Margaret Wurtele.

For more information about the Publisher's Circle and other ways to support Coffee House Press books, authors, and activities, please visit www.coffeehousepress.org/pages/donate or contact us at info@coffeehousepress.org.

JUSTIN PHILLIP REED is an American writer and amateur bass guitarist whose preoccupations include horror cinema, ideological failure, and uses of the grotesque. He is the author of two poetry collections, *The Malevolent Volume* (2020) and *Indecency* (2018), both published by Coffee House Press. Born and raised in the Pee Dee region of South Carolina, he participates in alternative rock music cultures, ogles Toyota Tacomas, and enjoys smelling like outside. His current favorite band is Oklahoma City's Chat Pile.

With Bloom Upon Them and Also with Blood was designed by
Bookmobile Design & Digital Publisher Services.
Text is set in Sabon Next LT Pro.